ARSHILE GORKY AND THE GENESIS OF ABSTRACTION

Arshile Gorky and the Genesis of Abstraction: Drawings from the Early 1930s

MATTHEW SPENDER / BARBARA ROSE

with Melvin P. Lader, Joseph P. Ruzicka, Martin Kline, and Sarah E. Lawrence

The Art Museum, Princeton University

Milwaukee Art Museum

The Baltimore Museum of Art

STEPHEN MAZOH & CO., INC., NEW YORK, 1994
Distributed by the University of Washington Press,
Seattle and London

EXHIBITION DATES

The Art Museum, Princeton University, October 29, 1994–January 3, 1995

Milwaukee Art Museum, January 20–April 16, 1995

The Baltimore Museum of Art, October 18, 1995–January 21, 1996

Published by Stephen Mazoh & Co., Inc., New York, 1994

Distributed by the University of Washington Press, Seattle and London

Copyright © 1994 Stephen Mazoh & Co., Inc.

ISBN 1–886055–00–9

Library of Congress Card Catalogue Card Number 94–078407

Contents

Acknowledgments

This exhibition and catalogue could not have been realized without the sympathetic cooperation and generosity in many ways of members of Arshile Gorky's family, Mougouch Fielding, Maro and Matthew Spender, and Natasha Gorky Young.

Matthew Spender's insights and continual assistance, together with Maro Spender's gracious patience and concern, even in the face of endless late-night calls and faxes, nurtured the growth of this project from its inception at their very home in Tuscany in the summer of 1993.

Melvin P. Lader, generous to a fault, shared with us his intimate knowledge of the subject, gave wise insightful advice, and helped lay the groundwork for all aspects of the catalogue. In the entries themselves, otherwise unreferenced quotations by Lader are taken from the original research he did for this project.

Joseph P. Ruzicka exhaustively examined the physical properties of every work, facilitating immeasurably efforts to read and understand the drawings' contents as well as the probable order in which they were made.

Sarah E. Lawrence gave invaluable assistance, not only in reviewing analyses of the drawings, but in correcting fledgling efforts at prose, relentlessly drilling us on acceptable sentence structure and rational vs. unintelligible verbal constructions.

Heather Johnson overwhelmed the computer with her lightning speed, barely equaled by the machine itself, in rendering the material organized and legible.

A final polish and perfection, if that may characterize any parts of the various texts, was assured by the very experienced scrutiny of Sheila Schwartz.

Despite her late entry into this project, Barbara Rose's encouragement and enthusiastic participation sharpened insights and invaluably enlivened what work remained. Her essay arrived in our hands despite daunting hurdles—the all too common syndrome these days of computer breakdown.

Last mentioned on the home team, but most important to the total project and its realization, is Martin Kline, whose calm, controlled and disciplined application of always lucid energies oversaw every dimension of the project, from the initial idea, to the selection of drawings and their framing, to the catalogue, its development and design, texts and editing, and to clearing the haze of chaos and panic that I inadvertently contributed to the workplace with predictable regularity.

Among the institutions and individuals who helped us secure supplemental material, thanks to: Thomas D. Grischkowsky and Mikki Carpenter at The Museum of Modern Art; Tamantha Kuenz at the Philadelphia Museum of Art; Suzanne Warner at Yale University Art Gallery; Nancy Sojka at The Detroit Institute of Arts; Allan Stone Gallery; Anita Duquette at the Whitney Museum of American Art; and Mrs. Alexander Sandow.

STEPHEN MAZOH

Foreword

This exhibition and accompanying catalogue includes thirty-nine drawings, many neither shown nor published before, that display the richness of Arshile Gorky's production as a draftsman over several years crucial to his development. The show offers a rare look at a singularly creative moment for Gorky. With pen and ink, pencil and paper as the primary vehicles of expression, he explores and develops a broad abstract visual vocabulary. Documenting the emergence of Gorky's unmistakably unique and intensely personal pictorial language, the exhibition examines the complex relationship among six themes developed in these drawings and their eventual connection to Gorky's 1934 proposed mural project for the Public Works of Art Project (PWAP). These six themes reveal the evolution of Gorky's highly inventive imagery, offering deep insight into a synthetic creative process that draws from both Renaissance and contemporary sources. These drawings not only mark the origins of Gorky's genius, they also reveal his working methods, demonstrating the systematic rearrangement of self-referential motifs that became major iconographic and thematic sources throughout his working life.

Introducing the catalogue are essays by Matthew Spender and Barbara Rose, both focusing on works in the exhibition directly related to the mural design "1934" (cats. 1–32 and 39). Indirectly related through imagery, the *Khorkom* series (cats. 33–38) is included to demonstrate how formative motifs were developed by Gorky in the early 1930s and remained essential elements in his later work.

MARTIN KLINE

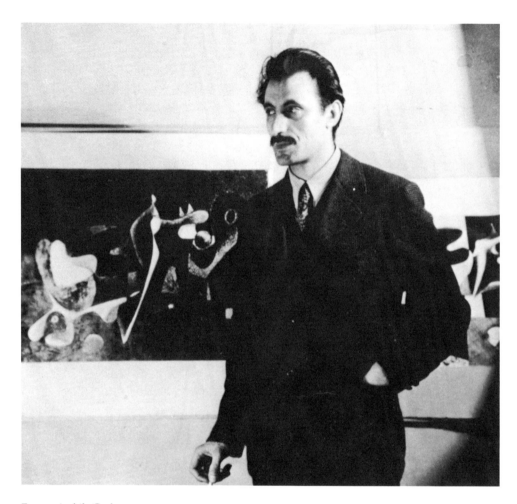

Fig. 1 Arshile Gorky
(as reproduced in *The Drawings of Arshile Gorky*, College Park, 1969)

Arshile Gorky: Themes for the Mural "1934"

By Matthew Spender

In about 1932 Arshile Gorky met Holger Cahill, future director of the Federal Art Project, the section of the WPA founded to help artists who had been hurt by the Depression. Cahill wrote a warm and intelligent paragraph for the catalogue introduction to Gorky's first one-man show at the Mellon Galleries in Philadelphia in 1934: "Arshile Gorky has an extraordinary inventiveness and fertility in creating special arrangements both precise and harmonious, and he contributes to contemporary American Expression a note of intellectual fantasy which is very rare in the plastic art of this country."[1]

A lecture was scheduled for the opening of this exhibition, and the *Philadelphia Enquirer* reported, with the mildest touch of irony, "Mr. Gorky gave a lecture at the galleries on Monday afternoon and those present declare he made everything quite clear."[2] Gorky had been teaching for eight years by this time, and was capable of giving a lecture on any aspect of modern art exhaustively, fluently, and with "an earthquake-like effect on sentence structure and a savagely perverse use of words to mean something they didn't."[3]

It was probably Holger Cahill who encouraged Gorky to seek a commission from the Public Works of Art Project, the institution which preceded the FAP. One drawing led to another until they became an interlocking series, culminating in the design called "*1934.*" The project never came off, but the best of these drawings were subsequently exhibited in a second one-man show in Philadelphia in the fall of 1935, which Gorky also introduced in person.

The drawings in this present catalogue form part of a series which Gorky drew between 1931 and 1934, though one or two might conceivably have been made after the latter date. They come together in a composition for which *Study for Mural* (cat. 39) is a maquette. A description of this composition was presented by Gorky to the Public Works of Art Project in December 1933 and there was also a large drawing, measuring 30 x 123 inches, which Gorky brought into the New York bureau of the PWAP on 8 West 8th Street, on February 13, 1934. This work has unfortunately been lost, but Lloyd Goodrich, then a member of the Regional committee, gave it his approval and asked Gorky to execute a painted version of the right-hand section in color. He warned Gorky not to make the largest edge of the painting longer than 40 inches—a necessary caution to an artist who had just walked into the office with a drawing 12 feet long.

On February 16 Gorky wrote on a form that he would begin immediately to paint a detail of the right-hand section of "*1934,*" placing a cheerful question mark opposite the envisaged "date of completion." This was the day after his first one-man show, with Holger Cahill's introduction, had closed. He was probably eager to take on the new challenge. But in April he was taken off the rolls of the PWAP, which collapsed in June 1934. On August 1, the Federal Art Project was founded to replace the defunct PWAP, with Holger Cahill as director. Gorky immediately joined, and from then on his energies were taken up with the various proposals for

an airport mural, which culminated two years later in the panels for Newark Airport. The mural "1934" was never executed.[4]

Although this exhibition includes thirty-nine drawings, the subject matter consists of not more than half a dozen themes, each with numerous variants. There is an intensity in producing a large group of drawings restricted to such a small group of motifs. Though some paintings resulted from the series, the drawings went far beyond the parameters of studies for easel works.[5] The usual explanation for this is that Gorky in the early thirties was too poor to afford paints, but this is unlikely. Besides the assistance he received from the FAP, Gorky instructed classes twice daily at the Grand Central School. He also had two private pupils who paid him about $15 a month each, and was exhibiting regularly.

When it came to drawing, Gorky was proud of quantity as well as quality, and liked to see not just individual works but whole portfolios mount up in the corner of the studio. Drawing, to Gorky, was as much a source of energy as an expenditure of it. According to Balcomb Greene: "In order to approach a canvas, he first had to feel a super-human adroitness. The hours of laborious and frenzied drawing, alone in his studio . . . were principally exercises of feeling his facility. I make the distinction between his feeling it and having it, as he then made the distinction between the creative act of painting and the feeble or botched material thing which was a sign of this action."[6]

There is no way of telling which image came first in the series, so it is merely my guess that Gorky started with a fairly straightforward copy from a painting by Picasso, *Figure au bord de la mer* (Fig. 6), which he found in a catalogue of a Picasso exhibition at the Galerie Georges Petit in Paris (June 16–July 30, 1932). Thumbprints of oil paint and sketches in the margin reveal the attention which Gorky gave this booklet of black-and-white Picasso reproductions. Many of the drawings in the present exhibition must have grown from this catalogue of works by Picasso. Gorky firmly believed in copying the works of former masters, although his copies are often quite strange and individual. He copied the *Famille Forestier* by Ingres so many times that in the end he would copy it upside down, the hem of Julie Forestier's dress becoming a distant mountain.

According to Melvin P. Lader, currently working on the catalogue raisonné of Gorky's drawings, there are over fifty versions of *Nighttime, Enigma and Nostalgia* (cats. 23–32), and the fact that Gorky produced such a large quantity of drawings of just one composition requires some explanation, or at least an analysis of what he produced. In these works drawing begins as a spontaneous adventure, a source of fresh material, rather than an exploitation of things already known. Of course once the particular "object" has been recognized on the page, it can acquire increasing definition, by adding cross-hatching, or a web of vertical and horizontal lines, or diagonals, or flat areas of matte black, all of which one can see in Gorky's series. Indeed, it often looks as if in some drawings Gorky were forcing the material toward a graphic equivalent of color or of paint, while in others he leaves the composition at its most empty and transparent.

There came a point, of course, when what was natural or spontaneous by

accident acquired almost too much definition. A fragment of a diagonal would become the edge of a table, indicating recession. A vanishing point might make its presence felt, and what was free might become dragged back into traditional illusionism. Just as in later years Gorky complained of the difficulty of ridding his Virginia drawings of the horizon line, so one can imagine that the *Nighttime, Enigma and Nostalgia* series represents a constant struggle with classical perspective, which forced the "objects" to sit at a certain distance from the picture plane.

Having made three or four *écorché* figures in the style of Cézanne early in the thirties, Gorky came across a seventeenth-century anatomical drawing by Amé Bourdon (Fig. 14) in the 1934, no. 3, issue of *Cahier*, published by the Abstraction-Création group. The article, called "Man and His Body," discusses the image of man as revealed by old anatomical engravings which, while intended to be scientific, in fact convey a poetic image of the human form. The article followed an earlier discussion of this theme in the English edition of *Formes* for March 1931. Gorky had here studied the plate of an anatomical figure held to a wall by a rope. He might also have read the text, rendered more poetic by literal translation from the French: "The flesh of the cheeks rises in stylized petals of iris, the tongue shows itself, the teeth-range a fantastic semi-circle set between the two holes of the vacant eyes."[7]

When, toward the autumn of 1933, Gorky set about preparing a design for a mural, probably at the prompting of Holger Cahill, I imagine that he placed in one long row all the work he had accumulated so far and began to think of ways in which to incorporate the material into a composition suitable for a mural. Cat. 20 follows the Amé Bourdon anatomical drawing, and cat. 27 shows how Gorky fitted this newly acquired image into another composition.

Like a series of Chinese boxes, the images are made to fit one into another. In two cases, Gorky took the composition of another artist to help him on his way. Cats. 23–26 show *Nighttime, Enigma and Nostalgia* inserted into a composition by Giorgio de Chirico, called *The Fatal Temple* (Fig. 16). I suspect that it was John Graham who introduced Gorky to de Chirico's work. Graham would have been fascinated by de Chirico's esoteric imagination. Gorky probably used *The Fatal Temple* just for its composition, but it is also true that he and de Chirico had much in common: the sensitivity of exile, and a great respect for the classical world. The words "enigma" and "nostalgia" were key words for de Chirico as well as for Gorky. "Enigma" appears above the image of a fish, in fact a drawing of a Ferrarese cake-mold, toward the lower right of de Chirico's composition.

Gorky used another painting in exactly the same way as *The Fatal Temple*. This time the work chosen was *The Profanation of the Host* by Paolo Uccello (Fig. 26). The painting, which Gorky never saw in the original, depicts the story of the arrest and execution of a Jewish family, accused of setting fire to a consecrated Host. I doubt whether Gorky followed the narrative content of this beautiful but disturbing work. He took from it the key compositional element of the column which appears at regular intervals to divide the sequence of narrative events. It stands between the "before" and "after" of the moment when the Host was actually cast into the fire, as it stands between the "before" and "after" of the execution of the Jewish

family. Gorky borrowed Uccello's column as a means of dividing space in his own composition, just as he took, in different areas of his final design, the walls drawn in steep perspective and the decorative floor, in order to establish the flattened and receding planes.

Gorky's 1933 application to the Public Works of Art Project contains a description of his pictorial intentions in the mural "*1934*":

> My subject matter is directional. American plains are horizontal. New York City in which I live is vertical. In the middle of my picture stands a column which symbolizes the determination of the American nation. Various abstract scenes take place in the back of this column. My intention is to create objectivity of the articles, which I have detached from their habitual surroundings so as to give them the highest realism.[8]

One of the requirements of the PWAP commission was that works should depict "the American scene," so "the determination of the American nation" is clearly a camouflage designed to satisfy this condition. Otherwise the text is really about the art of drawing. It is full of classic examples of Gorky's "perverse use of words to mean something they didn't," as Stuart Davis put it. For example, whereas the word "objectivity" usually means "non-subjective," Gorky means "of objects." When Gorky says that his design is "directional," it refers to nothing more than awareness of recessive lines in the composition. "*1934*" has little to do with "horizontal American plains" or "vertical New York City," and much to do with verticals and horizontals.

Few of Gorky's images should ever be analyzed iconographically, and to do so in the case of "*1934*" would to be to misunderstand the artist's intentions entirely. The drawings provide a lesson of the pictorial grammar by which a composition is made, and where the objects of which the image is made stand in relation to the composition. "Objectivity of the articles" in Gorky's description of "*1934*" means that the elements in the drawings are "objects," shorn of their context. They are "detached from their habitual surroundings so as to give them the highest realism." A few years later Gorky wrote an autobiographical account of his ideas for the files of the Museum of Modern Art. Once again he talked of the principle of "the poetic elevation of the object." This was "the marvel of making the common—the uncommon!" To Gorky, this was "the modern miracle. Through the denial of reality, by the removal of the object from its habitual surrounding, a new reality [is] pronounced."[9] In other words, the objects of this world are neither symbols, nor vehicles for some narrative, but are in themselves containers of emotion. In this respect, Gorky's ideas never changed.

1. Introduction to Mellon Galleries exhibition, Philadelphia, February 2–15, 1934, The Museum of Modern Art, New York, archives.

2. *Philadelphia Enquirer*, February 11, 1934.

3. Stuart Davis, "Arshile Gorky in the 1930's: A Personal Recollection," *Magazine of Art* (February 1951).

4. Archives of American Art, Ethel Schwabacher papers. See also Francis O'Connor, "The Economy of Patronage," *Arts Magazine*, 50 (March 1976), p. 95.

5. There are two paintings each of the compositions *Nighttime, Enigma and Nostalgia* and *Image in Khorkom*. No other important paintings came from the themes in this exhibition.

6. Balcomb Greene, in a text written in 1950 and deposited in the Whitney Museum, published in *Arts Magazine*, 50 (March 1976), p. 110.

7. Pierre Mornand, "The 'Corporis Humani Fabrica' of André Vesale as Interpreted by Th. Gemini," *Formes*, no. 13 (March 1931).

8. PWAP application form, December 20, 1933, National Archives, Washington, D.C.; quoted in Newark 1978, p. 22.

9. Gorky, essay in *Art for the Millions*, ed. Francis O'Connor (Boston: New York Graphic Society, 1975), pp. 72–73.

Arshile Gorky: The Genesis of a Master

By Barbara Rose

> *The poet should define the quantity of the unknown which awakes in his time, in the universal soul. He should give more than the formula of his thought, than the annotation of his march toward progress. The enormous becoming the normal, when absorbed by everyone, would really be a multiplication of progress.*
>
> Arthur Rimbaud, as quoted by Arshile Gorky in "My Murals for the Newark Airport."[1]

In 1930 Arshile Gorky moved his studio from Sullivan Street near Washington Square uptown to a vast space at 36 Union Square. The gifted twenty-six-year-old artist was already gaining recognition. Indeed, that year he showed work at the new Museum of Modern Art. Tall, handsome, and elegant, Gorky was the lively young companion of Stuart Davis and John Graham, avant-garde painters who had worked in Paris. Their sophistication and firsthand experience of modern French painting identified them as the major theoreticians of the emerging New York School. It is a testimony both to Gorky's intellectual brilliance, sometimes unrecognized because of his foreign accent, as well as to his immense talent that Davis and Graham chose him to join their battle for modernism as the "third musketeer."[2] Both men contributed to Gorky's development, but by the end of the decade, he had left his mentors behind to discover his own singular path. Later Graham became an embittered eccentric, who turned against Picasso, abstraction, and the automatic procedures he had championed at the point that Gorky was recognized as a young lion by the Surrealists.[3] But Gorky's rupture with Davis, the Cubist-Realist who translated Léger's urban imagery into American vernacular, was more abrupt. It was also more significant ideologically and stylistically, as an examination of the emergence of Gorky's mature concerns during this crucial period of his development will reveal.

It was most likely within the short period from 1931 to 1934 that Arshile Gorky produced a remarkable series of large works on paper. They served as the incubator of his evolving plastic language. Rather than a dry spell, the early thirties was a fertile period of introspection and invention for Gorky. After only a decade in the United States, it appeared that his career as an artist was about to take off. The Crash of 1929 that ushered in the Great Depression had wrecked the art market and with it Gorky's hopes for solvency. Material hardship, however, did not stop his rapid development of a style that synthesized Cubist structural and formal concerns with Surrealist content and techniques. Legend has it that Gorky sacrificed everything to his art, at times going hungry to buy precious materials, and that, as the situation became more difficult, he was forced to confine himself to works on paper. However, as Matthew Spender points out, the truth is that Gorky did not devote himself to drawing because he could not afford paint and canvas: he drew because he loved line and its expressive potential and because drawing permitted

him to develop spontaneity, skill, and a new repertoire of motifs that he could utilize later in his paintings. At the memorial after Gorky's tragic death in 1948, Stuart Davis quashed this bohemian tall tale of poverty, recalling that during the Depression Gorky was relatively well-off and that he would go on buying sprees in Greenwich Village, purchasing the finest materials in impressive quantity.[4]

Gorky painted relatively little in the early thirties. Drawing became the means to distill a personal vocabulary of forms and symbols from the traditions he inherited, studied, copied and finally mastered. Ultimately Gorky's superiority as a draftsman, his commitment to *disegno* as well as to *colore*, gave him a unique position in the pantheon of the New York School. Indeed, his synthesis of the polarities of Western art defined his style as a modern master who wished to join "the great group dance," as he termed the collective creative spirit. William Seitz, an early champion of the artist, first called attention to the importance of this mysterious group of large black-and-white drawings from the early thirties in "Arshile Gorky: Paintings, Drawings, Studies," the exhibition he curated in 1962 for the Museum of Modern Art. The works are exceptionally beautiful but problematic with regard to date, style, and meaning, both formal as well as iconographic. Seitz recognized that they were pivotal for Gorky's development. He focused, however, on the two motifs that were later developed in paintings, *Khorkom*—ultimately renamed *Garden in Sochi*—and *Nighttime, Enigma and Nostalgia*, the image around which the largest group of drawings was developed.

According to Seitz, "The *Nighttime, Enigma and Nostalgia* motif was obsessively redone in more than twenty almost identical versions, in several variations and in combination with other images."[5] The palette-pelvis-heart is among Gorky's most identifiable forms, a key to his multivalent poetic symbolism. Seitz described the motif as "an interlocked complex of curved shapes that resemble an artist's palette with its eye-like projections."[6] This much repeated palette shape is drawn by Gorky in a way that suggests both the life-sustaining pulsations and emotional center of the heart as well as the erotic area of the pelvis. This characteristic organic form originates in the drawings under consideration. Its interpretation as a surrogate for the painter, his emotions and sexuality, expressed through the medium of the work, appears so clear as to be intentional on Gorky's part. Indeed, the identification of mind, body, and heart with the act of painting indicates a rare level of personality integration and is central to the singular power of Gorky's art.

The 1931–34 works on paper are a unique record of Gorky's progressive evolution from the representational to the fully abstract. In these drawings, he developed his new concept of "reality" based on the discovery of the hyperreality of dreams and the concept of the unconscious that the Surrealists extrapolated from Freud and Jung. The drawings are so closely related in theme and format that they can be thought of as a series. Six different themes are discernible: Cubist standing figure (cats. 1–6); column with objects (cats. 7–13); organic abstraction (cats. 14–16); male *écorché* (cats. 17–22); *Nighttime, Enigma and Nostalgia* (cats. 23–32); *Khorkom* (cats. 33–38). Sometimes combined, the themes undergo considerable permutation as Gorky refines them. Several drawings (cats. 8–10, 26, 33) are worked both recto

and verso; others show pencil *pentimenti*, indicating they were transferred from previous drawings, a practice common to academic methods of translating drawing into painting and prints.

It is difficult to date the majority of these drawings. However, their motifs are first discernible in a series of lithographs Gorky printed himself in 1931. With the exception of the *Khorkom* theme, which could date as late as 1936, we presume that the majority of these drawings were executed before February 1934, when Gorky submitted a pen-and-ink preliminary sketch for a mural to the Public Works of Art Project, the government agency that preceded the WPA. When Gorky received this assignment, his first mural commission, in December 1933, wall painting was a major issue for ambitious artists of his generation. The example of the Mexican muralists, Siquieros, Rivera, and Orozco, who painted, taught, and lectured in the U.S. in the early thirties, stimulated an interest in ancient, medieval, and Renaissance frescoes. While they were part of everyday reality in Europe, these works could only be seen in the New World in reproduction or, in rare cases, in museums. Willem de Kooning, for example, recalled the occasion when he, Gorky, and John Graham studied the Roman wall paintings from the villa at Boscoreale installed in the Metropolitan Museum.[7]

The dialogue concerning mural vs. easel painting was a major topic, as important as the arguments over subject matter, content, and abstraction vs. representation. Gorky was a key participant in these aesthetic battles. His close friend John Graham praised the greatness of Uccello, who became a special hero to the New York School. In fact, Gorky's student, Ethel Schwabacher, identified the main source of the 1934 mural sketch as Uccello's predella panel *The Profanation of the Host* (Fig. 26). She also observed that Gorky had a black-and-white reproduction of the work as well as a plaster head after the antique in his studio.[8] A comparison of Gorky's 1934 mural sketch with Uccello's small panel reveals a similar tripartite structural organization. Gorky also borrowed a number of specific motifs, such as the column in the center, the tiled floor, and angled panels suggesting truncated perspective. The stage-set construction that Uccello has in common with de Chirico's metaphysical works also inspired Gorky's receding diagonal lines and repoussoir elements suggesting theatrical *coulisses*. Gorky also alludes to the self-conscious picture-within-a-picture convention that de Chirico appropriated from earlier art. Furthermore, Schwabacher identified de Chirico's *The Fatal Temple* in the Gallatin collection (Fig. 16) as the inspiration for the drawings depicting antique busts and fish.

The horizontal sketch for the 1934 mural corresponds to the arrangement of drawings visible in the well-known photograph of Gorky seated in his studio taken in 1933 (Fig. 2). We recognize the *Mannequin*, *Écorché*, and *Column with Objects* motifs pinned to the wall to the left behind Gorky. Behind the artist to the right, we see the *Nighttime, Enigma and Nostalgia* motifs. The date 1933 indicates that Gorky had already done a large group of drawings related to the imagery of the 1934 mural sketch, which he subsequently incorporated into the design for the project. The compositional organization uniting three separate earlier themes and suggest-

ing a progressive narrative or "evolution" seems to have been inspired by the Uccello panel: Uccello's floor tiles and receding perspective appear in the mural sketches that unite the various individual motifs for the first time.

The studio photograph indicates that Gorky had clearly been distilling the

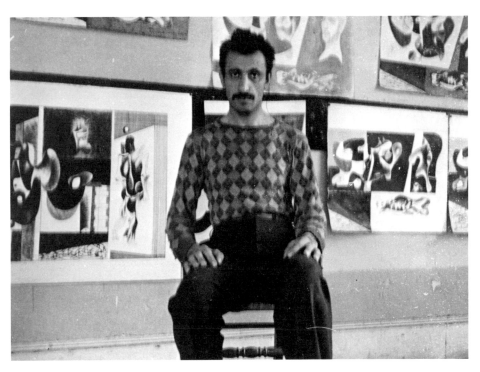

FIG. 2 Arshile Gorky Courtesy Dr. Alexander Sandow

material incorporated in the 1934 mural sketch for some time. Pinholes in the drawings reveal that they were tacked up and moved around. The long period of gestation, the reversals and inversions, the manipulation of an original template image—all signal the complexity and unity of Gorky's thought. A thorough investigation of the black-and-white drawings of the early thirties reveals that Gorky used line in every conceivable way it can be defined: as contour, silhouette, boundary, shading, decorative patterning, spatial inflection, rhythmic arabesque, and autonomous figuration. The exhaustiveness of his investigation of the definition of the linear brings to mind Jasper Johns' taxonomy and careful dissection of the elements of art.

Gorky submitted the finished 30 x 123-inch maquette for the mural project to the New York office of the Public Works of Art Project in February 1934. However, the mural, like many others for which sketches survive, was never executed, and Gorky was dropped from the PWAP in April. When the PWAP became the WPA/Federal Art Project in August 1934, Gorky was rehired. However, rather than continue working on his original project, he began an entirely different series of sketches in an altogether different style. These culminated in the 1936 murals for Newark Airport, recovered and restored in 1978, now in the Newark Museum.

By comparing Gorky's sketch for *"1934"* with the graphic Cubist-Realist design for the Newark murals, we see the artist suppressing his poetic style of free association and autonomous liberated line for a more down-to-earth Cubist conception of depicted shape and finite shallow space. No one has asked why Gorky abandoned the dream imagery, ambiguous space, automatic drawing, and phantasmagorical erotic content of Surrealism for the mundane objectivity, flat space, and industrial iconography of the Newark Airport murals. Gorky's life on the WPA was not easy. He was isolated from the masses temperamentally and artistically. He also had specific ideas about mural painting that were antithetical to the official agenda of state-sponsored "art for the millions." We can imagine his discomfort with being forced to illustrate the American Scene, the prescribed subject matter for WPA murals. In the end, Gorky gave up trying to please government authority, denouncing illustrational subject matter as "poor art for poor people."

The Newark Airport murals are decorative and geometric. They have a debt both to Picasso's 1927–28 studio interiors as well as to Léger's Cubist cityscapes that inspired Stuart Davis' successful fusion of Cubist syntax with American Scene subject matter. Léger's work was well known in New York. Gorky had a colored reproduction of his 1919 *The City* in the Gallatin collection.[9] In his 1934 mural sketch and related drawings, Gorky isolated objects, but made them fluid and viscous, concentrating on forms that suggested human anatomy and internal organs. The 1936 Newark Airport murals, on the other hand, depict hard-edged and mechanical shapes. Knowing where Gorky would turn next, we may imagine how stifling and antithetical to his vision he found Cubist-Realist images and iconography. His plunge into a private world of reverie, melancholy, and lyricism that produced the great works of his mature period is prefigured in this exquisite and uniquely coherent suite of drawings from the early thirties.

1. Quoted in Newark 1978, p. 15.

2. Schwabacher 1957, p. 43.

3. One may conjecture that the onset of Graham's insanity coincided with the independent breakthrough of his protégés, Gorky, de Kooning, and Pollock.

4. Francis O'Connor in Newark 1978, p. 25, estimates that Gorky earned a little over a $1,000 a year during the seven years he was employed by the New Deal projects.

5. MoMA 1962, p. 20. Melvin P. Lader has determined that there are over fifty versions alone of the *Nighttime, Enigma and Nostalgia* theme in its single trapezoid framed format, as in cats. 27–31.

6. Ibid.

7. *Willem de Kooning: Paintings*, exh. cat. (Washington, D.C.: National Gallery of Art, 1994), p. 79, clarifies de Kooning's debt to Gorky and provides new information on both. The two painters sanded their paintings in the thirties in imitation of the smooth surface of fresco painting.

8. Schwabacher 1957, p. 48.

9. Gorky lived within easy walking distance of the Gallatin Museum of Living Art, opened in 1927, which contained key works by Léger, Picasso, Gris, and de Chirico, as well as other important European masters.

Introduction to the Plates

Joseph P. Ruzicka

Most of the drawings in this exhibition are untitled, in keeping with Gorky's practice of not giving his works titles in his major solo exhibitions in the mid-1930s for which catalogues were produced: the exhibition *Arshile Gorky* at the Mellon Galleries (Philadelphia, February 2–15, 1934) and *Abstract Drawings by Arshile Gorky* at the Guild Art Gallery (New York, December 16, 1935–January 5, 1936). It does appear, however, that when a work entered a collection, Gorky was willing to title it. For example, he confirmed that the title *Objects* was the correct one for the drawing now in the Museum of Modern Art (Fig. 19).[1] Predictably, the lack of titles for these works has created confusion. For the purposes of this exhibition, if a drawing is clearly part of a given series, the title of this series serves here as the title of the individual work. The exhibition and catalogue are divided into six thematic groups. While several drawings contain elements of more than one theme, they have been organized under the following six headings: *Cubist Standing Figure*; *Column with Objects*; *Écorché*; *Nighttime, Enigma and Nostalgia*; and *Khorkom*. The last two themes, *Nighttime, Enigma and Nostalgia* and *Image in Khorkom*, derive their nomenclature from related paintings by Gorky to which he gave those titles.

A complete list of references and exhibitions has been provided for each drawing; a key to the abbreviations used in the entries and footnotes precedes the essays. The titles under which individual works were shown publicly are given after each exhibition reference. They demonstrate a practice of giving specific titles to drawings that Gorky habitually left untitled.

The type of paper used for each drawing has been noted, and where applicable, the watermark or embossed trademark has been transcribed. Many writers have commented that Gorky used only the finest material in his drawings of the early thirties, and this catalogue information bears out their assertions. It also indicates that Gorky used specific kinds of paper to achieve specific effects, and several entries deal with issues raised by this technique.

1. Collection Record Worksheet, Object file, Department of Drawings, The Museum of Modern Art, New York.

1. *Cubist Standing Figure* c. 1932–33

Graphite on off-white chain-laid paper

24³/4 x 18⁷/8" (62.9 x 47.9 cm)

Signed lower right, in graphite: *Gorky*

Watermark, left center: MBM (FRANCE)
Ingres d'Arches

FIG. 3 PABLO PICASSO
Untitled, July 28, 1928. Pen and ink on paper

The *Cubist Standing Figure* motif mirrors Gorky's debt to Picasso, and demonstrates his ability to appropriate and transform the work of others into inventions entirely his own. A group of drawings by Picasso of abstract figures on a beach, reproduced in the 1929 issue of *Cahiers d'Art*, identifies a source for this series (Fig. 3).¹ Gorky mimicked these drawings with a group of his own (Fig. 4), incorporating at right the same architectural profile, a cabana, here inverted. Another likely source is a 1928 Picasso: *Dinard—Design for a Monument*, on view at the Museum of Living Art in New York in the early 1930s (Fig. 5), and a Picasso of 1929, *Figure au bord de la mer* (Fig. 6),² with similar conelike breasts and rounded buttocks. Gorky retains essential elements from Picasso, but they are defined by new formal means, with the modeling more smooth, the pencil less vigorous, and the forms flatter. The cabana, occupying the right margin of the sheet, is a device used repeatedly by Gorky to open the picture space beyond the limits of the sheet. Gorky not only flattens form, but eliminates illusionistic space. Architecture, sky, and ground are reduced to a single plane in gradations from light to dark. Characteristic of every series, one version rendered solely in pencil fills the entire sheet, as in this instance. Although Gorky's exploration of flat geometric form relates to the Cubism of Picasso and Braque, he adheres only loosely to its rules and generates from it his own pictorial space.

1. Christian Zervos, "Projets de Picasso pour un monument," *Cahiers d'Art*, 8–9 (1929), p. 348.

2. Picasso's *Figure au bord de la mer* was included in the Galerie Georges Petit exhibition in Paris, June 16–July 30, 1932, fig. 187. According to Matthew Spender, p. x above, Gorky owned a copy of the exhibition catalogue and the reproduction of this painting is richly adorned with Gorky's annotations.

FIG. 4 ARSHILE GORKY
Untitled, c. 1941. Pen and ink on paper.
12 x 9" (30.5 x 22.9 cm).
Private collection

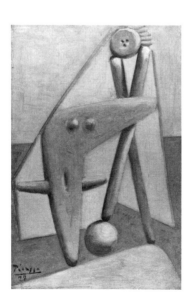

FIG. 5 PABLO PICASSO
Dinard—Design for a Monument, 1928.
Oil on canvas. 9¹/2 x 6¹/2" (24.1 x
16.5 cm).
Philadelphia Museum of Art, A.E.
Gallatin Collection

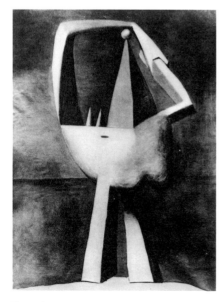

FIG. 6 PABLO PICASSO
Figure au bord de la mer, April 7, 1929.
Oil on canvas. 51 x 38" (129.5 x 96.5 cm).
Zervos VII, 252.

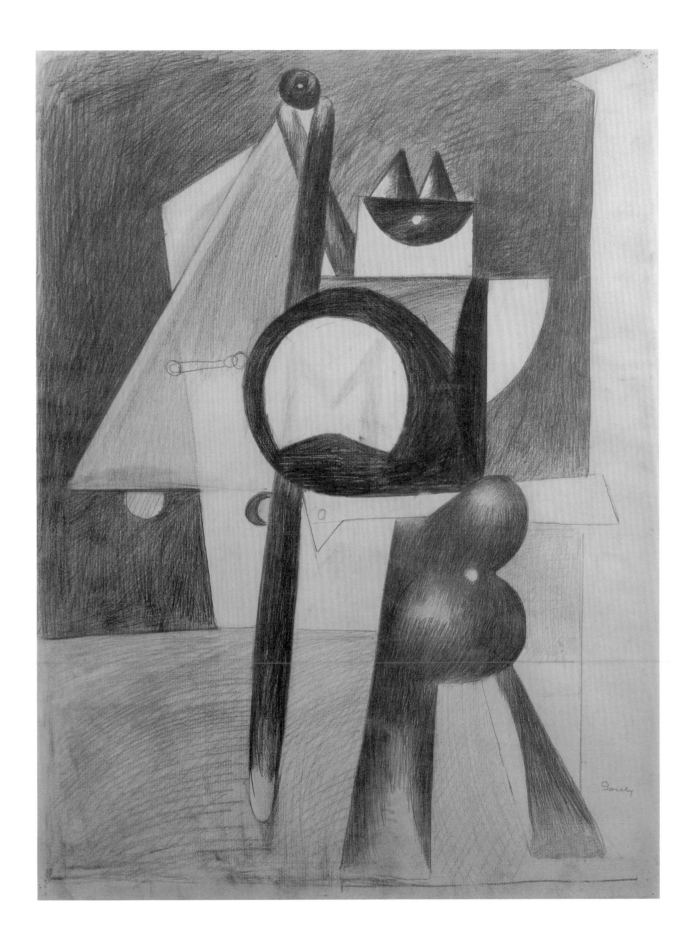

2. *Cubist Standing Figure* c. 1931–32

Graphite on chain-laid off-white paper

25 x 19" (63.5 x 48.3 cm)

Signed upper left, in graphite: *Gorky*

Watermark, center right edge: MBM (FRANCE) Ingres d'Arches

EXHIBITION: Guild Art Gallery 1935–36, no. 5.

Gorky consolidates the pictorial elements of the *Cubist Standing Figure* here, resulting in a more compact and legible suggestion of human form. He rotates the triangle left of center in the previous drawing, appropriating from Picasso the image of the figure's right arm reaching its head (Fig. 6). The buttocks shape now appears twice in profile as before, and again, rotated up forty-five degrees; in this new position, it is both a heart and a painter's palette. In the manner of Cubism, Gorky shows more than one view of a figure at the same time in a single image. The three landscape elements seen before—sky, ground, and architecture—occur again, but stop short of the paper's edge, foregoing the illusion of depth, but declaring the landscape's fictive nature. The figure is contained within this artificial space, but its right leg steps beyond and below the space, asserting again the two-dimensionality of the picture plane.

4

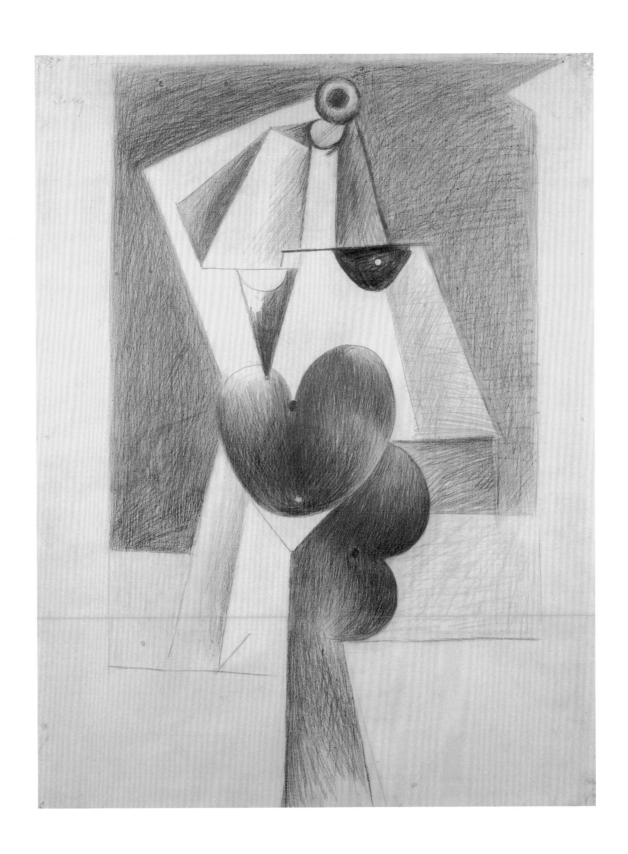

3. *Cubist Standing Figure* c. 1931–32

Pen and ink on drawing board

28 7/8 x 23" (73.3 x 58.4 cm)

Signed lower left, in fountain pen: *A Gorky*

Embossed upper left: STRATHMORE / TRADE MARK / DRAWING BOARD

EXHIBITION: Lausanne 1990, no. 3, p. 20 (*Standing Figure*, c. 1929–32)

Gorky here produces a richly finished variation in pen and ink of the *Cubist Standing Figure*. Dense hatching heightens the contrast between light and dark passages and projects the figure into the foreground. The sharp contrast of figure to ground is further intensified by the reduced scale of the image on the sheet. Once again, the figure strides out of its fictive space into an expanded void in the surrounding margins. The cabana has nearly been swallowed by this void, though its location is suggested by silhouette, intersected by the composition's right margin.

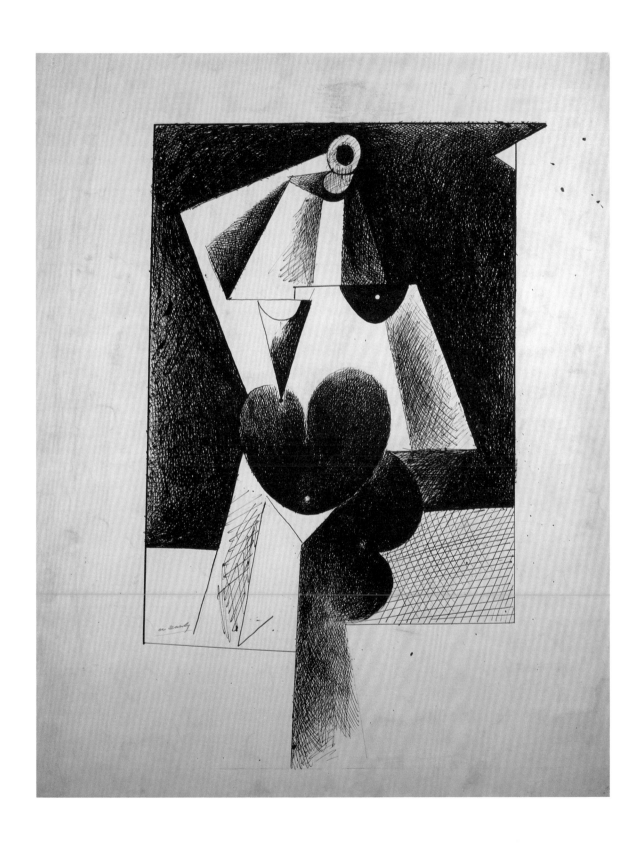

4. *Cubist Standing Figure* c. 1930–31

Graphite, white gouache, watercolor, brush and ink, and newsprint collage on joined pieces of paper

24 7/8 x 19" (62.9 x 48.3 cm)

Signed upper right, in graphite: *Gorky*

The figure's lower half retains the buttocks, palette, and legs in the somewhat simplistic format of previous versions. The upper half is radically reworked into a complex and vigorous geometry in this Cubist collage, one of the only two collages known in Gorky's œuvre. The former background setting disappears; the figure is instead now woven into a patchwork of flat geometric planes which surround it and with which it begins to fuse. All suggestion of illusionistic space is gone, limiting pictorial depth to opaque and transparent overlapping planes. Collage and horizontal striping aid each other to assert the literal flatness of the picture plane.[1] The sheet is texturally rich in its variation of graphite techniques and the layering of different kinds of paper, as well as in the use of newsprint and occasional passages of gouache.

Read as a crooked arm in cats. 1, 2, and 3, the upper left half of this *Cubist Standing Figure* no longer registers as an anatomical reference, but serves as a rhythmic termination of the composition along the left margin of the sheet.

According to Melvin P. Lader, "comparatively few paintings resulted from the hundreds of drawings Gorky made during the 1931–35 period. An exception is *Standing Figure Variation* (c. 1930–31; Jordan 1982, no. 89), which relates to this study."

1. "Horizontal stripes in a painting" are specifically recommended by John Graham as "the means and methods of creative articulation," in his *System and Dialectics of Art*, ed. Marcia Epstein Allentuck (Baltimore and London: The Johns Hopkins Press, 1971), pp. 162–63.

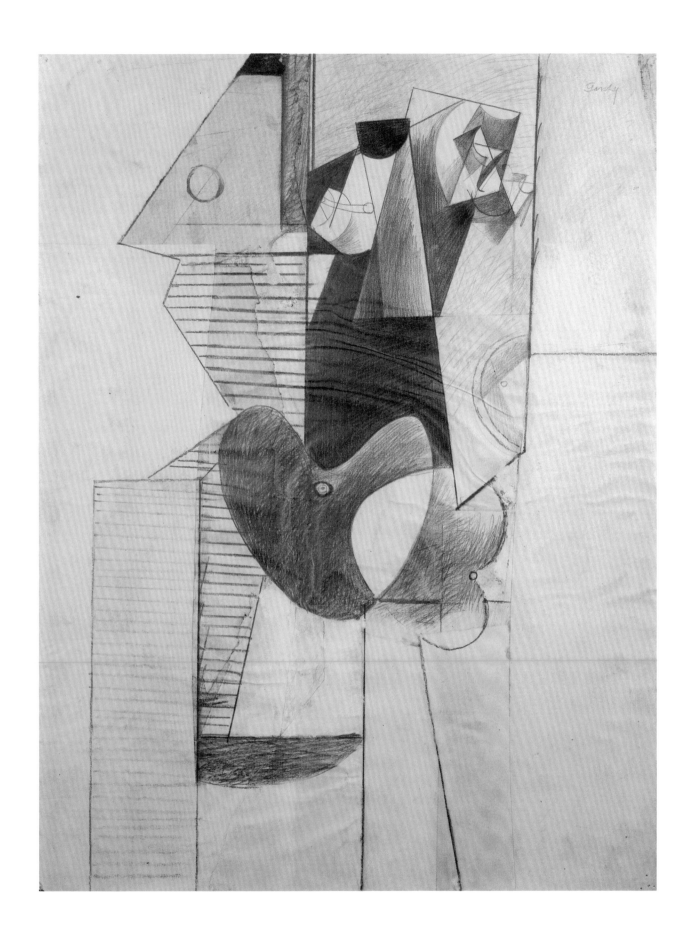

5. *Cubist Standing Figure* c. 1930–31

Graphite on chain-laid paper

25 x 19¼" (63.5 x 48.9 cm)

Signed lower right, in graphite: *Gorky*

Watermark, upper left: MICHALLET / FRANCE

In graphite alone, Gorky repeats the thematic elements executed in mixed media in the preceding work. His own words deftly identify his concerns in this drawing:

> What is the thrust of theoretical cubism? It is to break up the shape of the object, to explode it and contract it so as to indicate the fusion of space and the object. Cubism implies that space is not empty, that space is alive. Whenever an object strikes a two-dimensional surface, the space around the object becomes part of the object.[1]

1. Quoted in Karen Mooradian, "The Philosophy of Arshile Gorky," *Armenian Digest*, 2 (September-October 1971), p. 70.

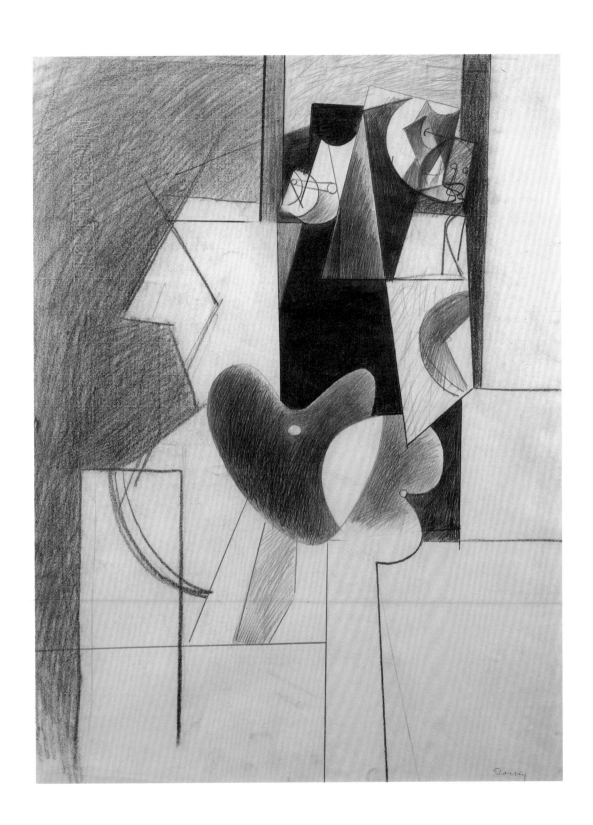

6. *Cubist Standing Figure* c. 1930–31

Graphite, and brush and ink on chain-laid paper

25 1/8 x 19 1/8" (63.8 x 48.6 cm)

Signed left center, in graphite: *Gorky*

Watermark, upper right: INGRES; upper left: CANSON & MONTGOLFIER / FRANCE; lower right: [monogram design]

This drawing is a much simplified reworking of the motif. The figure sits against and fuses with a white ground unworked but for its several designations of contiguous facets. Consequently, the reduced form has a much less substantial presence. The combination of intensely black passages and delicate feathery shading makes the figure almost weightless, yet anchored by its dense core.

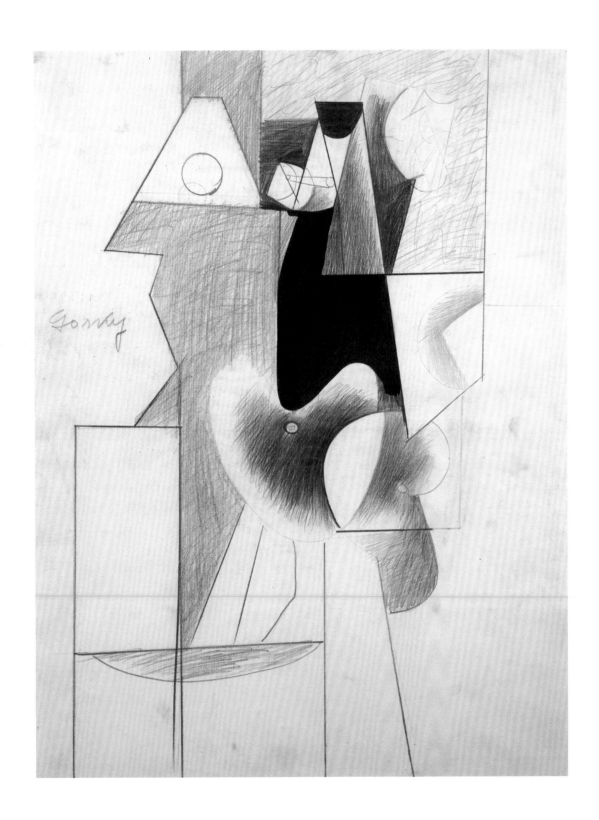

7. *Column with Objects* c. 1932–34

Graphite on chain-laid paper

19 x 25" (48.3 x 63.5 cm)

Not signed

Watermark, upper center, upside down: MBM (FRANCE) Ingres d'Arches

Column with Objects is a series of compositions that contains both abstract and representational elements. Left of the fluted pillar, two angular rhythmic shapes, one black, one white, each at times positive and negative in its oscillating encounter with the other, are reminiscent of the *Cubist Standing Figure*'s left profile in cats. 4 and 5. The central motif of *Column with Objects* is a vertical construction of surprisingly disparate elements, fusing architectural parts, globes, a loaf of bread, and an ornate letter box. Suspended behind this fantastic construction, a curious cloudlike shape hovers ominously. Another undefinable form anchors the lower right corner of the drawing, less smoothly modeled and finely articulated than the cloudlike shape above, and perhaps patterned after Max Ernst's *Monument aux oiseaux*, 1928, reproduced in *Cahiers d'Art* of that year (Fig. 7).[1] The entire right edge of the composition is bordered by the familiar cabana image, in the same location throughout this series, which implies the continuation of the scene. The space within the composition is puzzling, with only occasional rational depth. The size of this drawing is identical to successive versions in this series and appears to be the actual template for the subsequent variations, which were transposed onto larger sheets of paper.

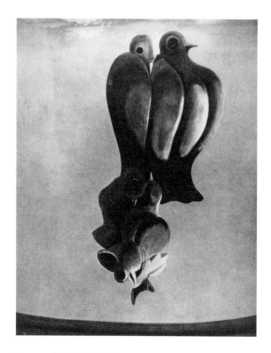

FIG. 7 MAX ERNST
Monument aux oiseaux, 1927. Oil on canvas. 64 x 51¼" (162.6 x 130.2 cm). As reproduced in *Cahiers d'Art*, 2 (1928)

1. Jean de Bosschière, "Max Ernst," *Cahiers d'Art*, 2 (1928), p. 73.

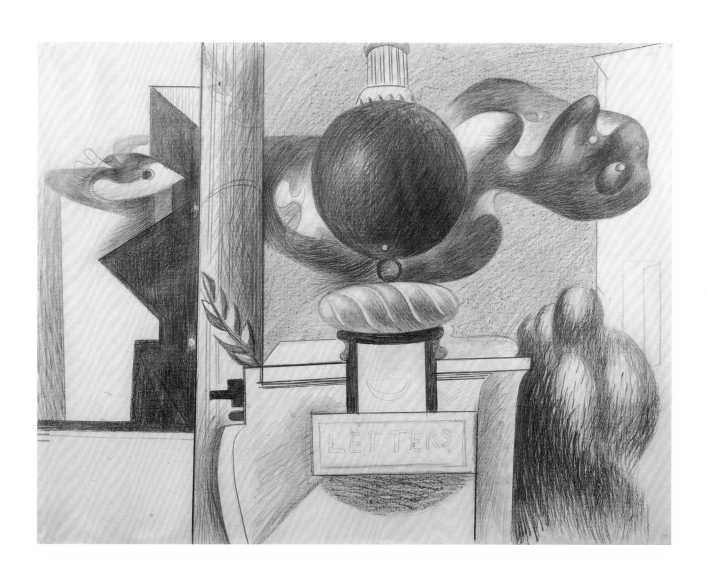

8. *Column with Objects* c. 1932–34

Pen, brush and ink, and graphite on drawing board

22⁷/₈ x 29¹/₈" (58.1 x 74 cm)

Signed lower right, in ink: *Gorky*

Signed lower left, verso: *Arshile Gorky by AGP*

Embossed lower right: STRATHMORE / TRADE MARK / DRAWING BOARD

REFERENCE: Rand 1981, fig. 4–16, pp. 64, 68.

More precise definition is given to each element in this pen-and-ink version of the theme, with heightened contrasts between dark and light. The composition withdraws from the edge of the sheet, bound by an ink border that is the exact measurement of the "template" drawing (cat. 7). The simplified elements are more stylized abstract shapes. Modeling gives way to more decorative surface treatment. The familiar heart-palette shape, faintly described in the upper left passage of the previous drawing, here takes flight in the shape of a bird.

On the verso is an unfinished drawing, heavily worked in areas, that appears to be traced from cat. 22.

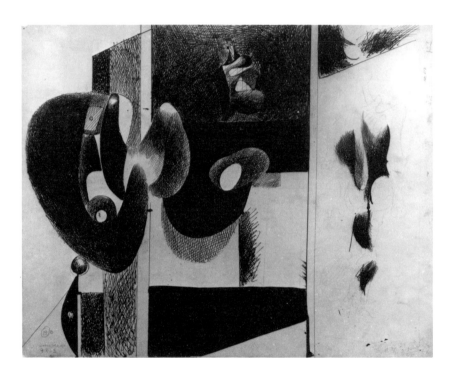

FIG. 8. Verso: pen, brush and ink, and graphite

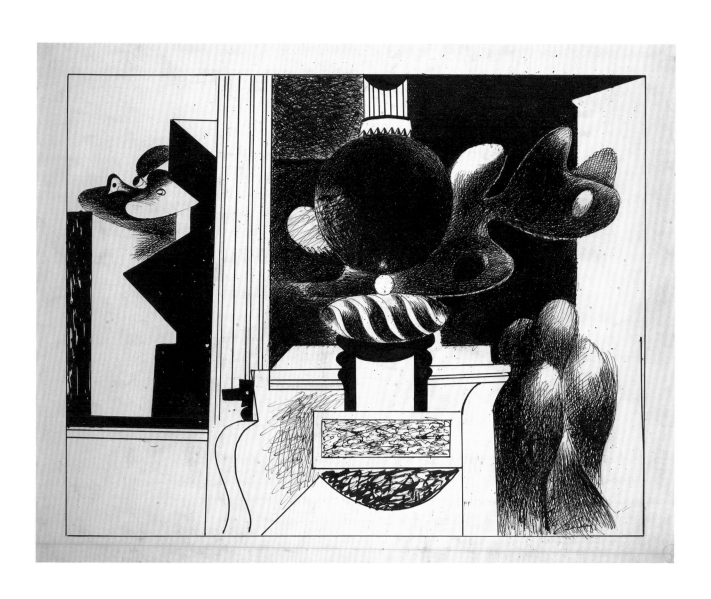

9. *Column with Objects* c. 1932–34

Pen, brush and ink, and graphite on drawing board

23 1/8 x 28 7/8" (58.7 x 73.3 cm)

Signed lower right, in graphite: *Gorky*

Signed lower left, verso: *Arshile Gorky by AGP*

Embossed upper left: GRUMBACHER ARTISTS PAPERS AND BOARDS / UNIQUE INSIGNIA

Atmospherically lighter and less brooding in mood, this version is softer overall in tonality, contained within the sheet by a drawn border as in cat. 8. This version of *Column with Objects* undergoes a further reduction in graphic ornamentation as highlights grow brighter. The central sphere seems to peel open, releasing a burst of light whose shape echoes the familiar heart-palette motif. The pen, in its reduced density, discloses a hand fraught with vigor and energy.

As in the previous drawing, the verso of this sheet (Fig. 9) is significant in the light that it sheds on Gorky's working method, in which the pen and ink is built up on a pencil tracing from a "template" drawing.

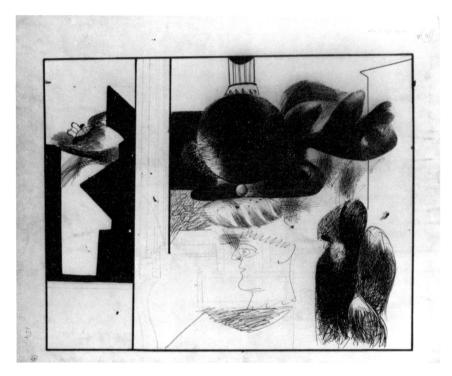

FIG. 9 Verso: pen and ink and graphite

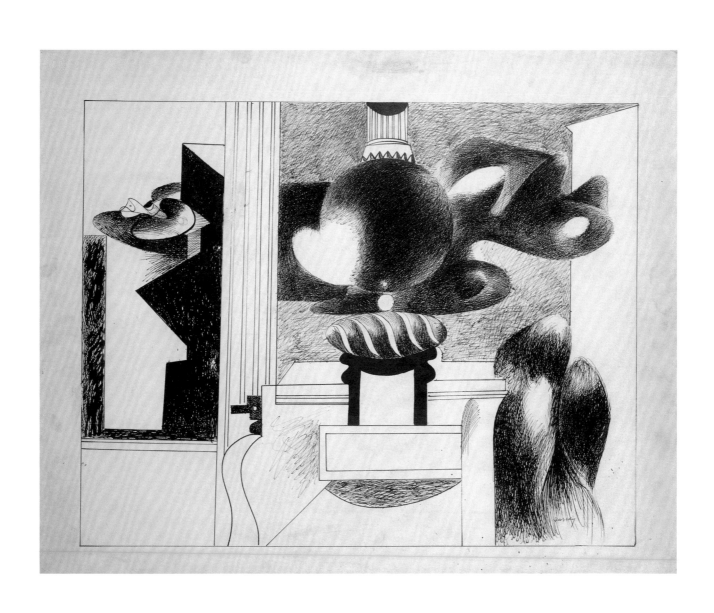

10. *Column with Objects* c. 1932–34

Pen, brush and ink, and graphite on drawing board

22³/4 x 29" (57.8 x 73.7 cm)

Signed upper left, in ink: *Gorky Arshile*

Embossed upper left, in reverse: STRATH-MORE / TRADE MARK / DRAWING BOARD

This signed variant of *Column with Objects* is unique here in its heavy outline, boldly defining the inanimate forms of the composition and compartmentalizing the pictorial space. Shading is thinner and more irregular, heightening contrasts throughout the drawing. With its light shading, the cabana no longer appears a white silhouette against the paper's right margin, but becomes a more solid architectural form. The peel-away heart-shaped highlight in the globe remains clearly legible, despite its partial bifurcation by the globe's contour. The preliminary pencil sketch of the bird-palette at upper left again reveals the use of the "template" drawing.

FIG. 10 Verso: pen and brush and ink

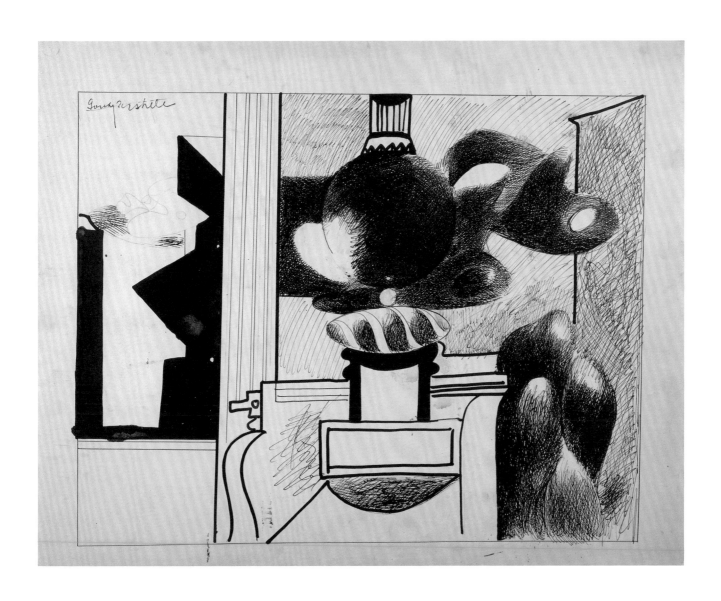

11. *Column with Objects* c. 1932–34

Pen and brush and ink on drawing board

23 x 28⁷/₈" (58.4 x 73.3 cm)

Not signed, recto

Signed lower right, verso: *Arshile Gorky by AGP*

Embossed lower left: STRATHMORE / USE EITHER SIDE

EXHIBITION: Newark 1978, no. 16, p. 78 (*Untitled*, c. 1934)

A rich array of graphic techniques—stippling, diaper patterning, cross-hatching, dense scribbling, flat washes, and spare line—displays Gorky's skilled and sensitive draftsmanship. The cabana motif, extending beyond the picture frame in other versions, is inverted here and in silhouette, defining the right edge of the pictorial field. Both it and the adjacent white area beyond become ambiguous, confusing the division of positive form and negative ground. The heretofore vaguely articulated birdlike cluster at lower right more convincingly declares itself a bird.

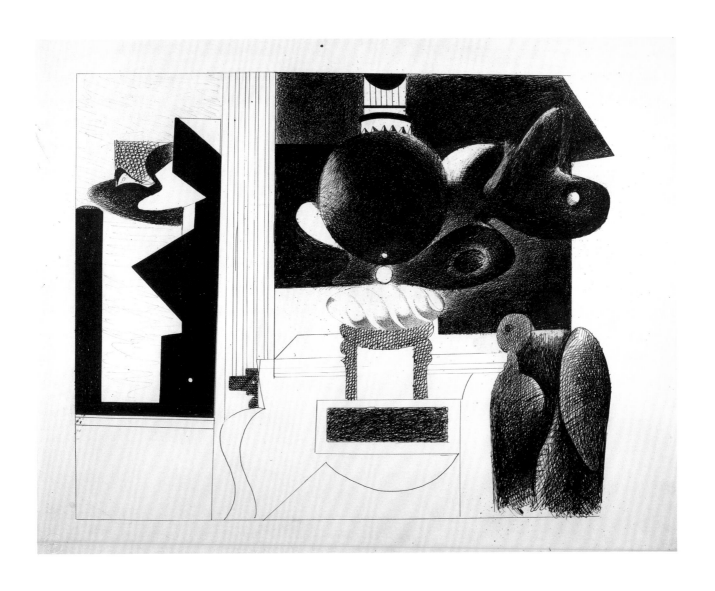

12. *Column with Objects* c. 1933–34

Graphite on off-white chain-laid paper

19 x 25" (48.3 x 63.5 cm)

Not signed

Watermark, lower center: MBM (FRANCE)

EXHIBITIONS: MoMA-IC 1963–68, no. 13 (*Untitled*, c. 1932)

Knoedler 1969, no. 2 *(Drawing*, 1932)

Guggenheim 1981, no. 48 (*Untitled*, c. 1932–34)

Lausanne 1990, no. 11, p. 23 (*Column with Objects*, c. 1932–34)

Venice 1992, no. 6, p. 48 (*Column with Objects*, c. 1933)

This version of *Column with Objects* uses similar motifs and format, but is nonetheless reconceived. The angular rhythmic black and white silhouettes to the left of the column give way to a head on a pedestal support whose profile resembles those of early Greek *kouroi*. The column is no longer continuous, but interrupted by a fluted midsection and decorated with a laurel branch pattern below (cat. 7). New to the composition are arrows, contained one within another and overlapping, a modern street sign perhaps appropriated from Stuart Davis. The bust and the arrow quietly confront each other from either side of the sheet. In place of the cabana and birdlike cluster on the right, a white and a black baluster, each at once a positive and negative shape, are present. This device is taken from Uccello's *Profanation of the Host* (Fig. 26). In an ambiguous resolution of space, the composition runs into the paper's edge on three sides but is contained within its own drawn border on the fourth.

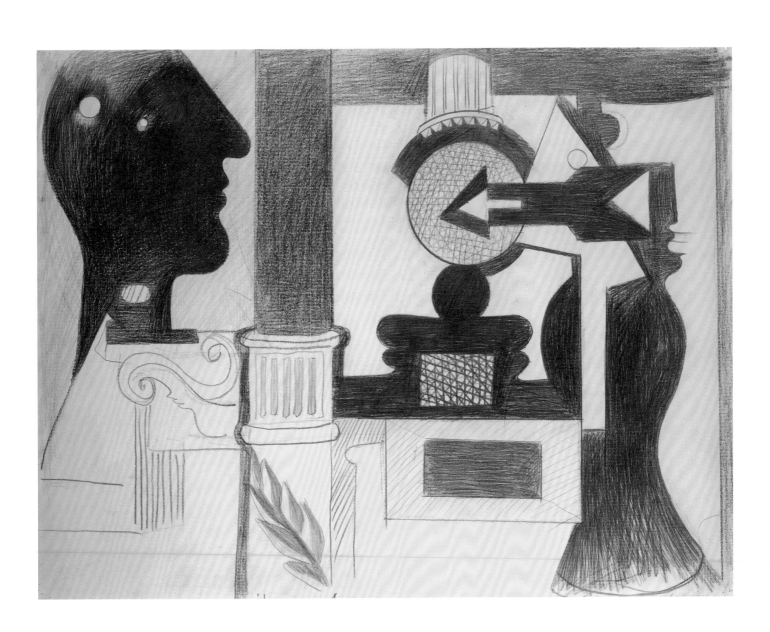

13. *Column with Objects* c. 1933–34

Graphite on off-white chain-laid paper

19 x 25" (48.3 x 63.5 cm)

Signed lower right, in graphite: *Gorky*

Watermark, lower center (in reverse): MBM (FRANCE) Ingres d'Arches

In this reformulated version of *Column with Objects*, the fluted column is reduced to a flat vertical strip and the stacked objects consist only of a modeled globe, a thickened heart-palette, and a profiled head which surmounts and intersects it. The distinctive jigsawed profile head, appearing in flat overlapping shapes, is a motif from Picasso's work of the twenties, which Gorky could have seen reproduced in *Cahiers d'Art* (Fig. 11).[1] The profile head at the left counterbalances the baluster at the right, contrasting a human and an architectural profile, organic and inorganic objects, the former in silhouette and the latter in outline. The space containing these various elements has both a wall and a floor—like a stage, with suggestions of conventional perspective, but without a truly rational three-dimensional space. The baluster and stage recall both Uccello's *Profanation of the Host* (Fig. 26), as well as Giorgio de Chirico's dreamlike stage settings. Lader notes that "a few years later, the artist also worked the motif of the face in profile into oil paintings such as *Composition with Head* and *Enigmatic Combat.*"[2]

FIG. 11 PABLO PICASSO
Seated Woman, 1927. Oil on wood. 51 1/8 x 38 1/4"
(129.9 x 97.2 cm). The Museum of Modern Art,
New York, Gift of James Thrall Soby

1. *Cahiers d'Art*, 3–5 (1932), pp. 166–67.

2. Jordan 1982, nos. 163, 176.

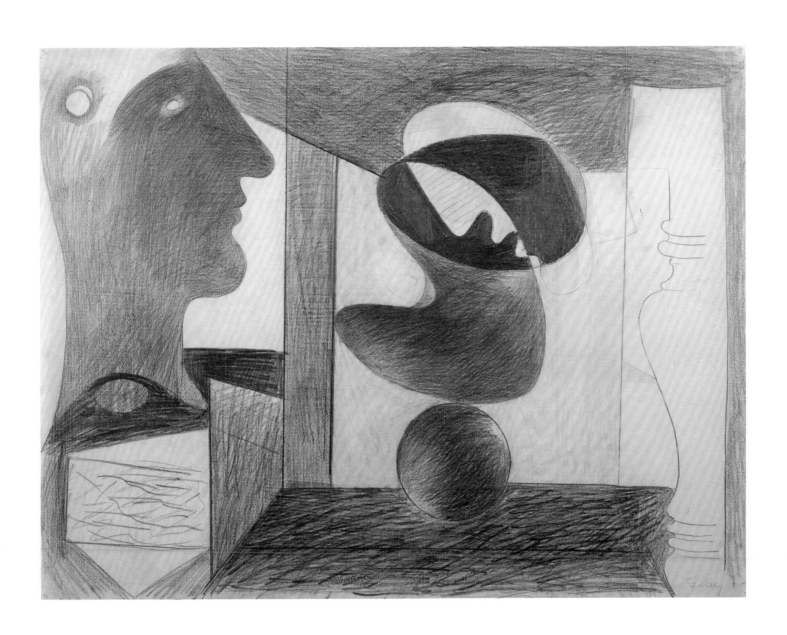

14. *Abstraction* c. 1931–32

Graphite on off-white chain-laid paper

19 x 25" (48.3 x 63.5 cm)

Not signed

Watermark, lower left: INGRES; lower right:
L'ECOLIER/C & F

EXHIBITIONS: MoMA-IC 1963–68, no. 12
(*Untitled*, c. 1932)

Knoedler 1969, no. 1 (*Drawing*, c. 1932)

Newark 1978, no 17, p. 79 (*Untitled*, 1932)

Guggenheim 1981, no. 48a(?) (no. 48a not on
checklist)

Lausanne 1990, no. 12, p. 57 (*Untitled*,
c. 1932–34)

Venice 1992, no. 7 (*Untitled*, c. 1933)

Further changes of *Column with Objects* occur in this and the two following entries. The classical profile now buttresses the entire right edge of the drawing and, like the cabana and column it has replaced, suggests the extension of the picture beyond the sheet's right boundary. Both the profile and the fish *écorché* derive from Giorgio de Chirico's *The Fatal Temple* (Fig. 16), a painting of central importance to Gorky's *Nighttime, Enigma and Nostalgia* series. Further, the headlike object surmounting a spindle recalls the mannequins which occur in many of de Chirico's paintings. A horizontal device of both solid and hollow shapes weds the profile to the headlike shape opposite. An intimation of depth, effected by the hollow within the bridge device, activates a three-dimensional irrationality at the core of the composition which echoes the picture's surrounding passages.

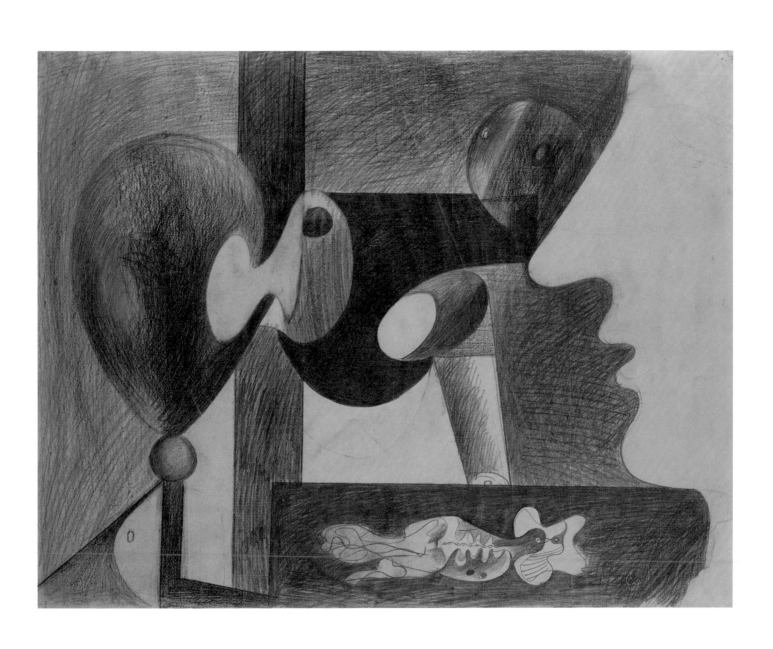

15. *Abstraction* c. 1931–32

Graphite on off-white chain-laid paper

19 x 25" (48.3 x 63.5 cm)

Signed upper left, in graphite: *Gorky*

Watermark, lower center: MBM (FRANCE)
Ingres d'Arches

The component parts here are essentially the same as in the previous draw-
ing. However, the formerly featureless mannequin head has assumed a stance
of hostile confrontation with the profile to its right. The bridge between them
stands suspended, more self-contained and with stronger intimations of
depth through and beyond itself. The fish *écorché* is unrecognizably abstract,
resembling the repertory of shapes found in the *Nighttime, Enigma and
Nostalgia* drawings. There exists the suggestion of illusionistic space, although
Gorky's primary thrust is the transformation of the three key figures.

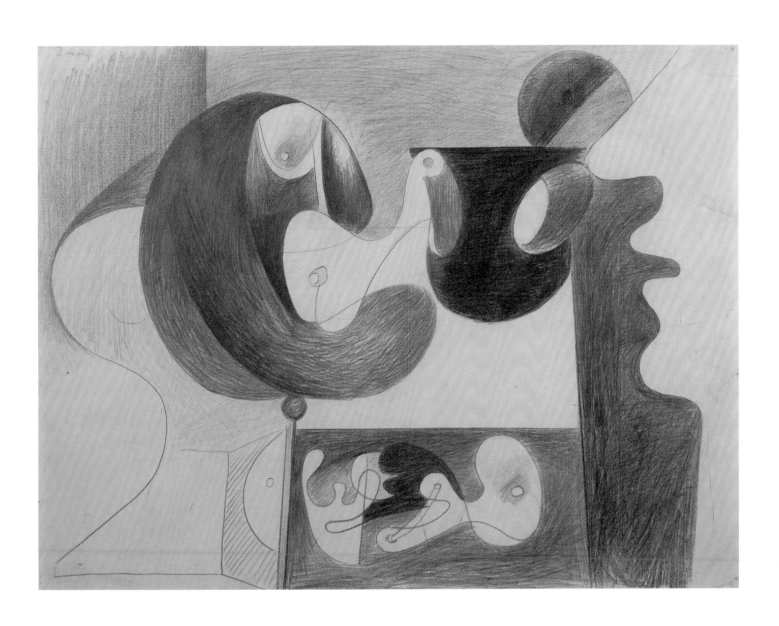

16. Abstraction c. 1931–33

Graphite on off-white chain-laid paper

19 x 25" (48.3 x 63.5 cm)

Signed lower right, in graphite: *Gorky*

Signed lower right, verso: *Arshile Gorky by AGP*

Watermark, top edge, upside down: MBM (FRANCE) Ingres d'Arches

Figuration is suppressed further in the simplification of this theme. The profile at right is replaced with a simple triangular plane, its flatness heralded by three X's, perhaps signifying the negation of the profile, yet functioning in the same manner and allowing the composition to suggest the continuation of itself beyond the sheet's edge. The connective bridge abuts a vertical panel, suggesting perspective. The mannequin, less fearsome, has developed mysterious activity within. The fish *écorché* is gone, leaving only a wood-grained panel, another de Chiricoesque element (Fig. 16). With figuration depleted, the strength in this work is largely architectural, relying on light and dark contrasts of a few simple elements and emphasizing straight lines to convey a sense of depth and scale.

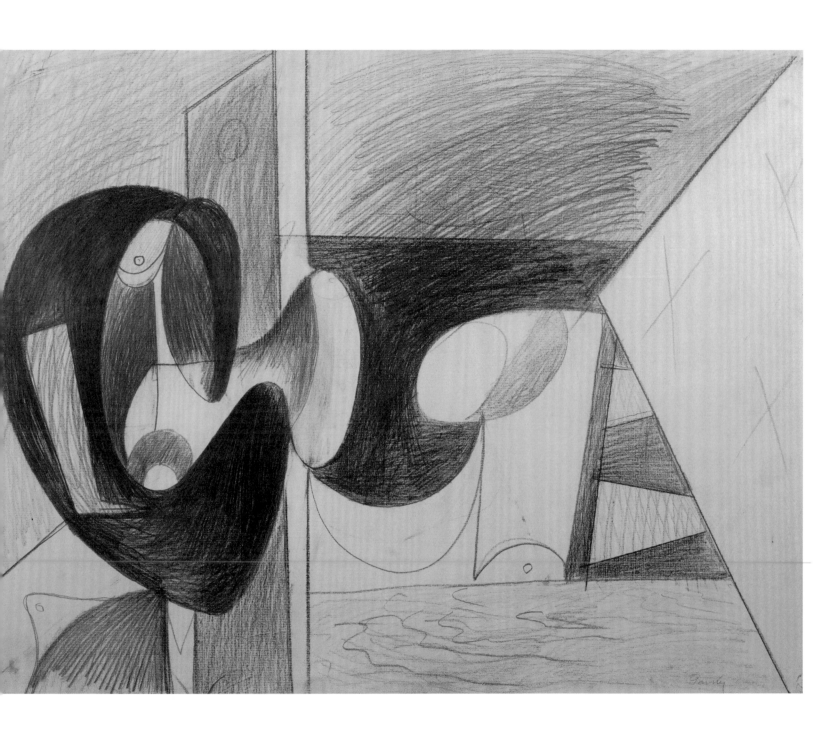

17. *Seated Male Figure* c. 1930–35

Pencil on paper

24¹/₂ x 18¹/₄" (62.2 x 46.4 cm)

Signed upper left: *Gorky*

EXHIBITION: Guggenheim 1981, no. 35.

This and the following three entries reflect Gorky's interest in abstracting the human figure in different ways. This seated male figure relates to another Gorky drawing of a woman with palette and paintbrush (Fig. 12). In both drawings the figures are similarly seated on a small bench, with the easel alongside the female artist echoed in *pentimento* in the drawing of the male nude. His setting has been altered, however, by the introduction of an ambiguous architectural outline that neither defines inside from outside, nor solid structure from open space, but nonetheless makes reference to the cabana seen in previous themes.

Like his contemporaries, especially Braque, Picasso, and Calder, Gorky builds the figure with continuous line and transparent form.[1]

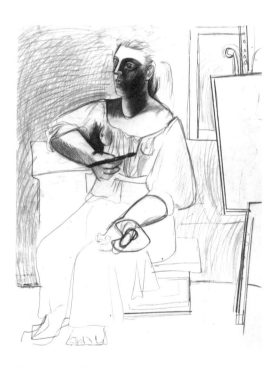

FIG. 12 ARSHILE GORKY
Untitled, c. 1930–31. Pencil on paper. 24¹/₈ x 19¹/₄"
(61.3 x 48.9 cm). Private collection

1. Works of this type by Calder and Miró are reproduced in *Minotaure*, 3–4 (1933).

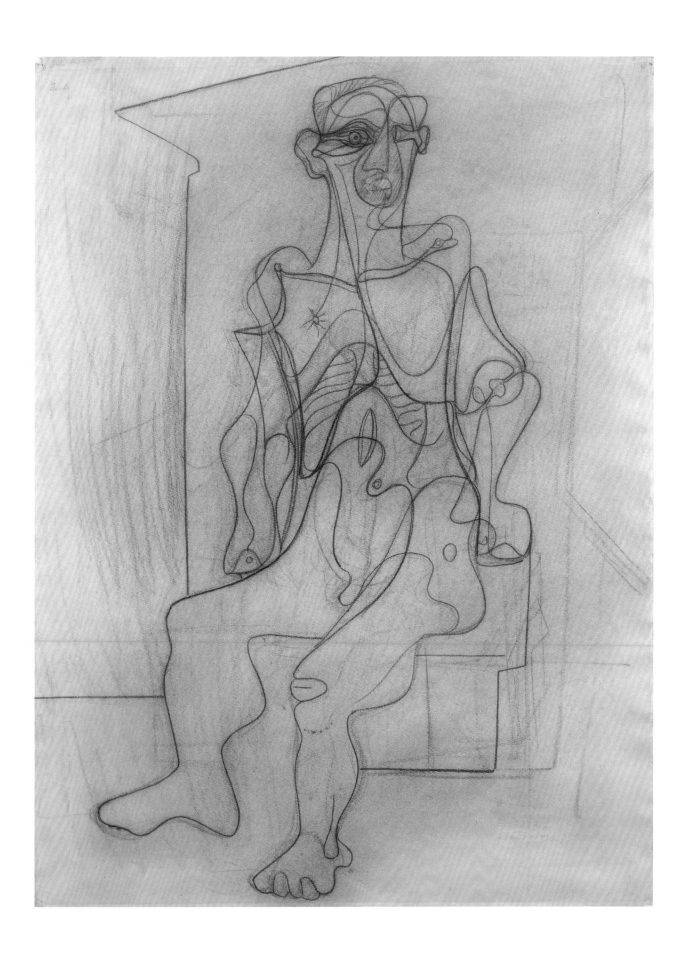

18. Écorché 1932

Pencil on paper

24 5/8 x 18 3/4" (62.5 x 47.6 cm)

Signed and dated, upper right corner: *Gorky, 1932.*

EXHIBITION: Lausanne 1990, no. 1, p. 46.

In this and the following drawing, Gorky used a plaster cast (Fig. 13), its original once attributed to Michelangelo, as his model for the study of stylized musculature.[1] Gorky owned and worked from plaster replicas of at least several classical sculptures. This particular cast presumably had neither head nor right hand if Gorky was faithful in his rendering of its features, here and in cat. 19. Rather than develop the full figure, Gorky concentrates on a rear view, exploring the abstract forms of the torso musculature.

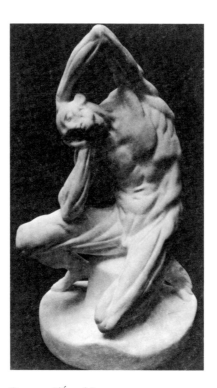

FIG. 13 *L'Écorché*
Plaster cast. Formerly attributed to Michelangelo

1. The original wax model, formerly in the Kaiser-Friedrich-Museum in Berlin, was mass-produced in plaster for use in art schools and studios.

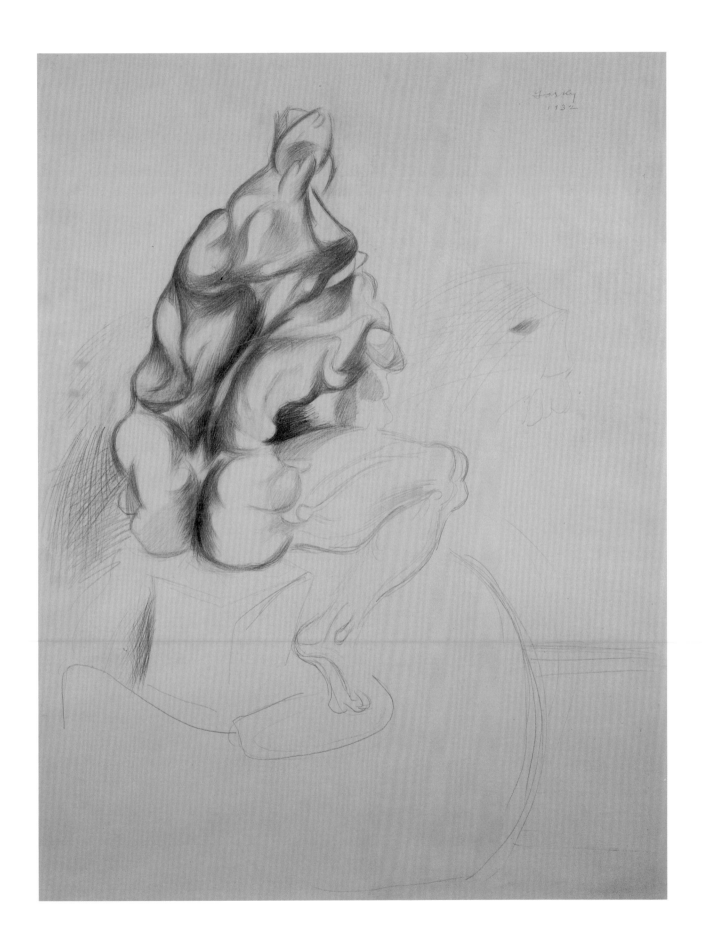

19. *Écorché* 1932

Pencil on paper

24³/4 x 19¹/8 " (62.9 x 48.6 cm)

Not signed

EXHIBITION: Venice 1992, no. 1, p. 39.

This version of the *Écorché* reiterates the musculature of cat. 18 with aggressive swirling shapes and dark ponderous modeling. The slightest hint of Uccello's *Profanation of the Host* (Fig. 26) is indicated just above the knee, where a single line shapes the baluster form.

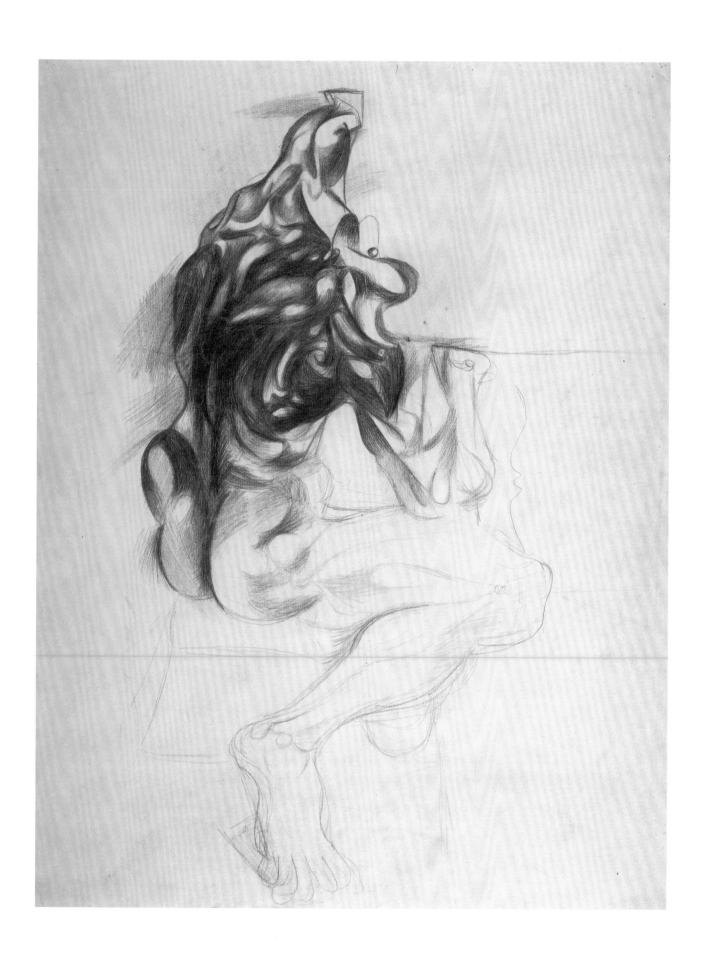

20. *Écorché* c. 1931

Graphite on paper

23³/₄ x 18" (60.3 x 45.7 cm)

Signed upper right, in graphite: *Gorky*

·EXHIBITION: Lausanne 1990, no. 4, pp. 20–21 (*Anatomical Study*, c. 1931–32)

Gorky adapted the *écorché* figure from seventeenth-century anatomical studies by Amé Bourdon (Fig. 14).[1] The *écorché* hangs from a rope, suspended from a receding wall, an architectural device used by Gorky before.[2] With its bare disjointed bones and ligaments, its skull less human than animal, the figure anticipates the birdlike head on the *écorché* in Gorky's 1934 mural design (cat. 39). An oculus is positioned directly above the figure. "Gorky's immediate source for the arangement of a figure before such a receding plane," notes Melvin P. Lader, "replete with the circle-crescent motif above, is a contemporary work titled *L'Enfant* (1931) by Mario Tozzi, which was reproduced in the periodical *Formes* in 1932."[3] The relationship of the figure to the wall and the picture space itself is once again ambiguous. The figure seems a shadowless two-dimensional appliqué on the wall which frames it, yet it slips away from the wall with the right foot casting a shadow in a passage of three-dimensional faceting. The rope from which the *écorché* dangles is preceded by the rope's own shadow, another moment of three-dimensional vision in this playfully confusing and inconsistent spatial conceptualizing.

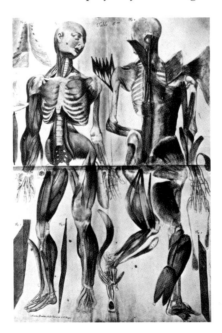

FIG. 14 AMÉ BOURDON
Écorché from *Nouvelles tables anatomiques*, 1675.
As reproduced in *Cahier*, no. 3 (1934).

1. These drawings were reproduced in "Homme et son intérieur," *Cahier*, no. 3 (1934), pp. 261f.

2. Another Bourdon drawing reproduced in the *Cahier* article depicts the flayed figure hanging from a rope.

3. *Formes*, no. 22 (1932). This issue was in Gorky's library. Information on Gorky's library courtesy of Matthew Spender. In Tozzi's work, a nude child is seen from the back in a position very reminiscent of Bourdon's *Écorché*.

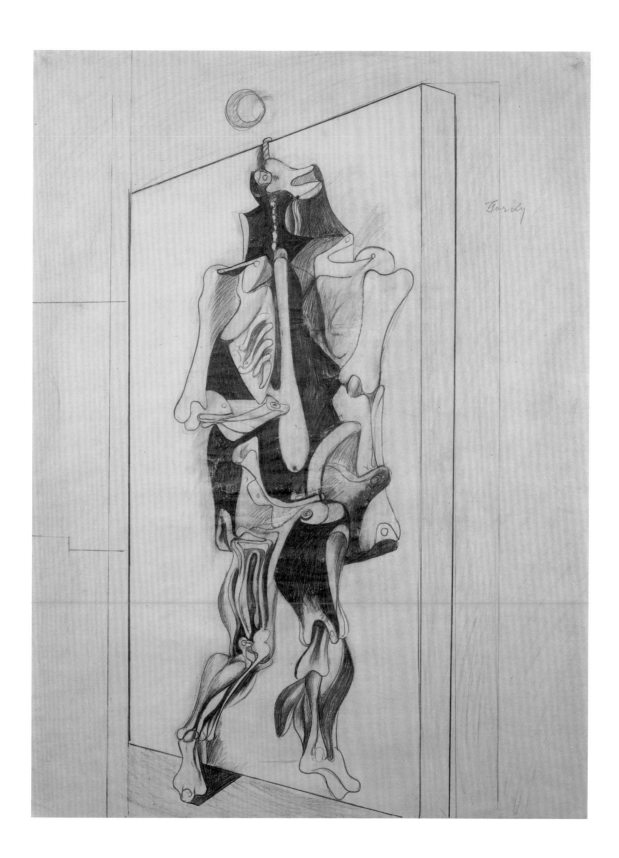

21. *Écorché* c. 1931–33

Pen, brush and ink, and graphite on heavy wove paper

22 1/2 x 13" (57.2 x 33 cm)

Not signed, recto

Signed lower right, verso: *Arshile Gorky by AGP*

EXHIBITION: Lausanne 1990, no. 14, p. 24 (*Écorché*, c. 1933)

The *écorché* figure is reworked with contrasts heightened by the introduction of darkened areas beyond the framed figure itself. The figure appears suspended and motionless, totally contained in an empty bright space. This sheet is very likely the remaining right side of a larger composition not unlike cat. 22. Gorky probably cropped this sheet himself, since its resulting proportions correspond to those of the previous drawing, cat. 20.

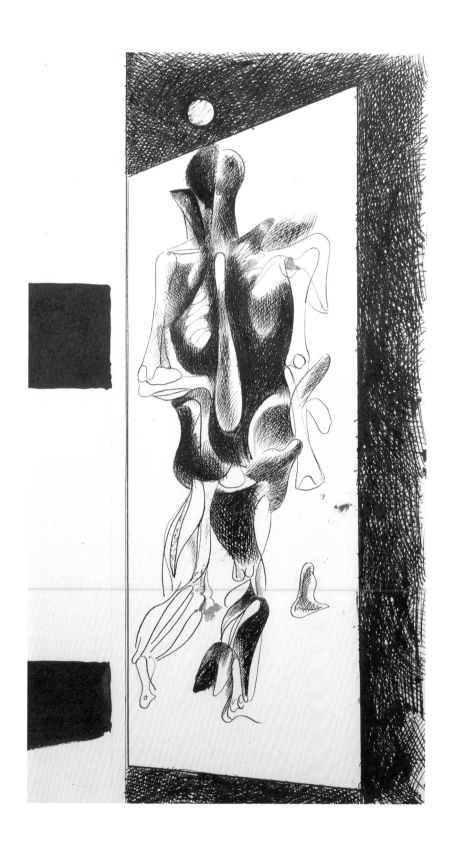

22. *Objects with Écorché* c. 1931–33

Pen and brush and ink on heavy wove paper

21³/4 x 30¹/4" (55.2 x 76.8 cm)

Signed lower right, in ink: *A Gorky*

EXHIBITIONS: MoMA 1962, p. 21 (*Drawing*, c. 1931–32)

Knoedler 1969, no. 11 (*Drawing*, c. 1931–32)

Newark 1978, no. 12, p. 74 (*Untitled*, c. 1931–32)

Guggenheim 1981, no. 47 (*Composition*, 1931–32)

REFERENCES: Schwabacher 1957, fig. 12, pp. 46, 50, 52

Ashton 1970, pp. 73–74

This last *écorché* merges the figure with a composition already seen in *Abstractions* (cats. 14–16). Closely resembling the previous entry, this *écorché* now occupies the right third of a three-part composition. The left two-thirds remain similar to *Abstractions*, with the addition of two new motifs in the central panel. The first of these, a capital E-shaped character, with the twin peaks from the Cubist drawing of cat. 1 resting on top, appears above. The second, at bottom, is a rectangle divided into two trapezoids, taken from de Chirico's *The Fatal Temple* (Fig. 16). This divided rectangle appears in many works of the *Nighttime, Enigma and Nostalgia* series. Through vertical partitions, the pictorial space is explicitly divided. This new composition must have been important to Gorky, as at least four finished versions (Fig. 15) and one unfinished version (Fig. 8) are known. This composition closely resembles the left third portion of the 1934 mural study (cat. 39).

FIG. 15 ARSHILE GORKY
Nighttime, Enigma and Nostalgia, c. 1931–32. Ink on paper. 24 x 31" (61 x 78.7 cm). Whitney Museum of American Art, New York, 50th Anniversary Gift of Mr. and Mrs. Edwin A. Bergman 80.54

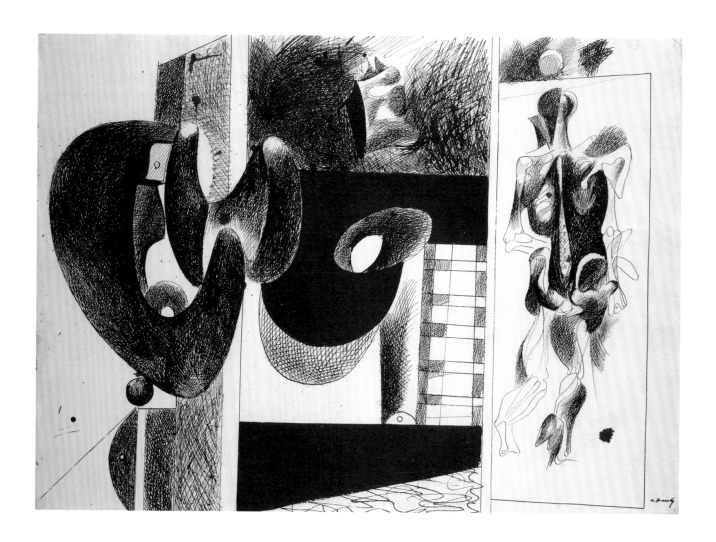

23. *Nighttime, Enigma and Nostalgia* c. 1931–33

Graphite on heavy wove paper

21¹/₂ x 29⁷/₈" (54.6 x 75.9 cm)

Not signed

EXHIBITIONS: MoMA-IC 1963–68, no. 6 (*Untitled*, 1929–32)

Rotterdam 1965, no. 27 (*Untitled*, 1929–32)

Knoedler 1969, no. 7 (*Untitled*, 1929–32)

Lausanne 1990, no. 9, pp. 22–23 (*Untitled*, 1929–32)

Venice 1992, no. 5, p. 46 (*Untitled*, c. 1932)

REFERENCES: Levy 1966, pl. 59

Karp 1976, p. 82

Guggenheim 1981, p. 31, fig. 21

Jordan 1982, pp. 37, 44, fig. 6

Ashton 1992, p. 23

This version of the *Nighttime, Enigma and Nostalgia* series has as its source Giorgio de Chirico's *The Fatal Temple* of 1913, which was on view at the Museum of Living Art (Fig. 16).[1] Following de Chirico, Gorky organizes the composition into unequal sections, places a classical bust to the right and a marinelike shape below it. He reworks these elements, however, the classical bust becoming a line drawing without modeling and the marine animal a skeletal abstraction, suggesting an *écorché*. The diagonally divided rectangle at bottom left mimics de Chirico. The largest portion of the composition on the left contains a characteristic Gorky abstraction in place of de Chirico's diagram. The capital E already noted in cat. 22 emerges indistinctly, again capped by two peaks, in the right half of this melodic abstraction. All de Chirico's signs, symbols, words, and diagrams have been eliminated. It should be noted, however, that "enigma" forms part of the inscription over the fish in de Chirico's painting and undoubtedly influenced the title Gorky gave to this series of drawings.[2]

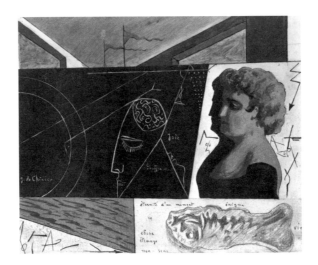

FIG. 16 GIORGIO DE CHIRICO
The Fatal Temple, 1913. Oil on canvas. 13 x 16" (33 x 40.6 cm).
Philadelphia Museum of Art, A.E. Gallatin Collection

1. The A.E. Gallatin collection was opened to the public as the Museum of Living Art at New York University in December 1927. De Chirico's *The Fatal Temple* is included on the checklist of the 1927 installation.

2. The phrase "nostalgic and enigmatic" is also used in reference to the art of Picasso by Gorky's close friend John Graham in his didactic treatise *System and Dialectics of Art*, ed. Marcia Epstein Allentuck (Baltimore and London: The Johns Hopkins Press, 1971), p. 171.

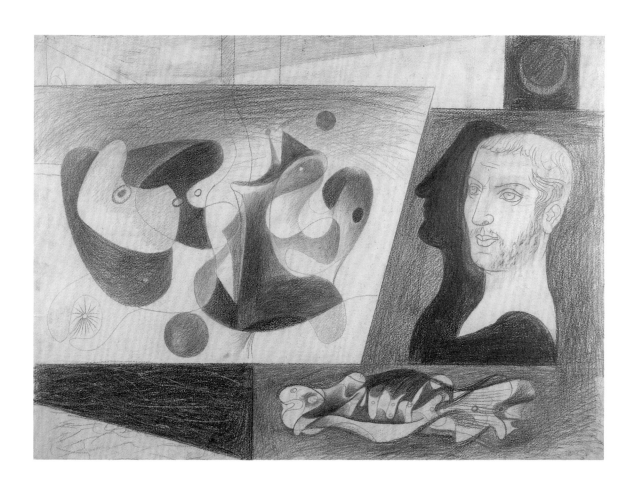

24. *Nighttime, Enigma and Nostalgia* c. 1931–33

Pen and brush and ink on drawing board
(with some erasing)

22 x 29¹/₂" (55.9 x 74.9 cm)

Signed lower right, in blue-black fountain
pen: *A Gorky*

Signed lower right, verso: *Arshile Gorky by
AGP*

Embossed upper left: [. . .] / [S]CHOELLER-
SHAMMER / DRAWINGART / REGISTERED
/ GERMANY

This pen-and-ink drawing closely follows the format of cat. 23. The medium modifies the effects. Contrasts of light and dark are intensified, offset by scumbled passages that create a mid-tone and animate the surface. The classical bust is modeled and has an intense expression, curious and imbalanced by its one dark, enlarged staring eye. Opposite it, the capital E emerges less prominently in the cryptic Gorkyesque abstraction. The drawing incorporates an enormous range of graphic techniques, combining various pen nibs and brush to vary the manipulation of the surface.

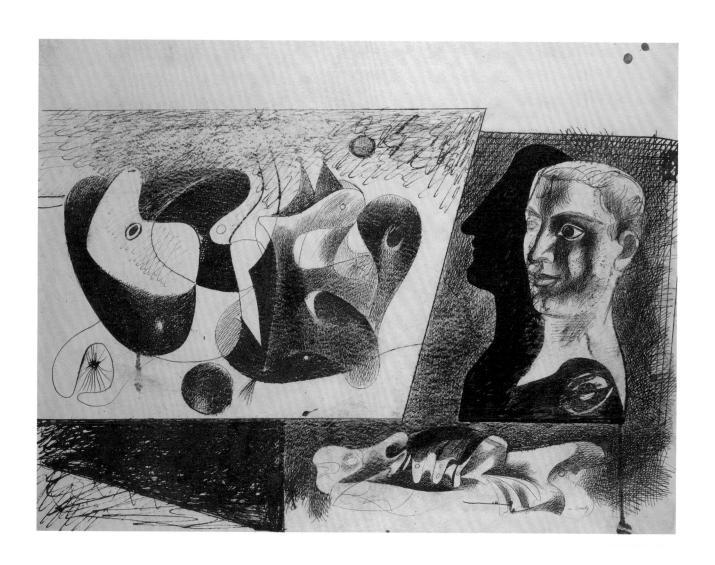

25. *Nighttime, Enigma and Nostalgia* c. 1931–33

Pen, brush and ink, and graphite on drawing board

22 x 30" (55.9 x 76.2 cm)

Signed lower right, in ink: *Gorky*

Signed lower left, verso: *Arshile Gorky / by AGP*

Embossed lower left: BALDRIDGE / DRAWING BRISTOL

In this version of *Nighttime, Enigma and Nostalgia*, Gorky makes the imagery increasingly his own as organization of pictorial space starts drifting away from de Chirico. Diaper pattern passages enhance the overall decorative effect of the abstract composition. The now not-so-classical bust is flattened into a Picasso-like profile (as in Fig. 11), alternately striped and diapered. Its previous shadow has grown a rounded contour, intersecting the profile and describing a second head, mannequin-shaped.

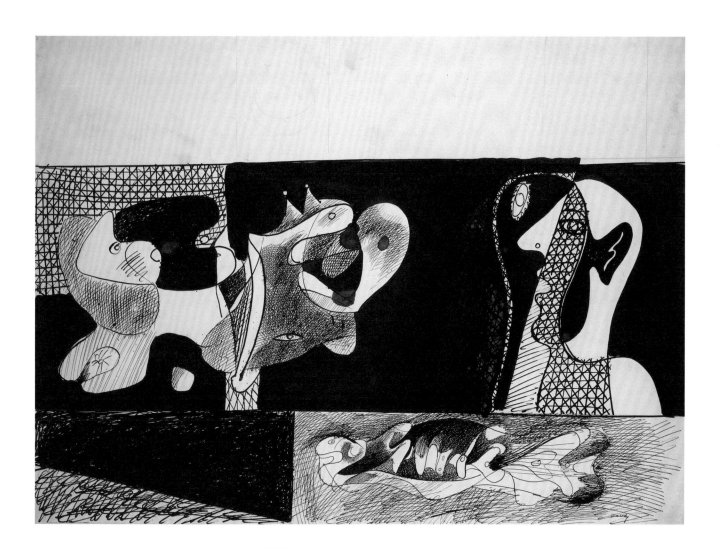

26. *Nighttime, Enigma and Nostalgia* c. 1931–33

Pen, brush and ink, and graphite on paper (with some scratching and erasing)

22³/4 x 29" (57.2 x 73.7 cm)

Not signed

Embossed upper left: STRATHMORE / TRADE MARK / DRAWING BOARD

EXHIBITIONS: Whitney 1951, no. 60, pp. 16, 19 (*Drawing*, c. 1932)

MoMA-IC 1963–68, no. 4 (*Untitled*, c. 1929–32)

Rotterdam, 1965 (?)

Guggenheim 1981, no. 36a (?) (not reproduced)

REFERENCES: Loftus 1952, pl. XII (reproduced upside down)

Schwabacher 1957, fig. 11, pp. 44, 50, 52

Rand 1981, p. 66, fig. 4–14

Melvin P. Lader finds this drawing "one of the most intricately and meticulously executed in the entire *Nighttime, Enigma and Nostalgia* series. The figures are clearly and precisely detailed, defined by a variety of pen strokes and cross-hatching techniques. An underlying meshlike screen unifies the ground of the drawing; the precision of these straight lines certainly disproves the commonly held belief that Gorky never used a ruler.[1] What had been a clearly recognizable head in the other related drawings in this catalogue has here become much more abstract. The back of the head is a flat, black, sharply outlined shell, out of the front of which flows an undulating organic form. Gorky pursued this avenue of abstraction in a number of other related drawings, including the one he began on the reverse (Fig. 17)."[2]

Although it is not known if this drawing was exhibited in the 1935–36 *Abstract Drawings by Arshile Gorky* show at the Guild Art Gallery in New York, certainly the following review might be applied to it:

> Gorky has an odd manner of almost completely covering his picture surface with thousands of little cross-hatched lines. On this practically black surface float weird, fantastic forms that, having no apparent or obvious meaning, are nonetheless so carefully set in their appointed place they carry the eye deep into the composition, achieve an exquisite balance of shape and tone (amazing how much color the artist had introduced into these black-and-whites), and set the whole arrangement into vibrating, arresting movement.[3]

FIG. 17 Verso: pen, brush and ink, and graphite

1. William Seitz, in MoMA 1962, p. 23, seems to have been the first to declare that "Gorky detested the use of a rule." Discussing the skillful draftsmanship in the whole *Nighttime, Enigma and Nostalgia* series, Diane Waldman, in Guggenheim 1981, p. 32, commented that "the sureness of his freehand line (he never used a ruler) is exceptional here."

2. Other related drawings are *Study for Nighttime, Enigma and Nostalgia*, c. 1932, private collection (Guggenheim 1981, no. 46); *Three Forms*, c. 1932, The Art Institute of Chicago (Rand 1981, p. 65); *Abstract Forms*, 1931–32, Albright-Knox Art Gallery, Buffalo (Rand 1981, p. 65).

3. *New York Evening Post*, December 21, 1935.

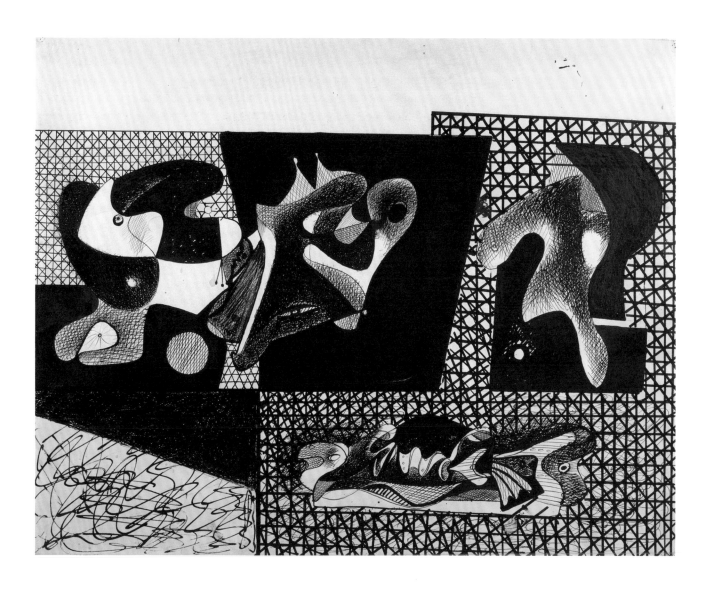

27. *Nighttime, Enigma and Nostalgia* c. 1931–33

Pen, brush and ink, ink wash, and gouache on heavy wove paper

13$\frac{1}{4}$ x 20$\frac{1}{2}$" (33.7 x 52.1 cm)

Signed lower right, in ink: *Gorky*

EXHIBITION: Lausanne 1990, no. 5, pp. 21–23 (Study for *Nighttime, Enigma and Nostalgia*, 1931–32)

The following six entries in this series isolate and elaborate the abstract composition from the upper left section of the composite *Nighttime, Enigma and Nostalgia*, but use the same title. This series marks the beginning of Gorky's singular visual vocabulary, mysterious, melodic and moving, devised and adapted by him to convey through pictures his poetic and provocative message.

Ethel Schwabacher described one way in which Gorky worked his drawings: "At times he washed off or erased surfaces before building them up again. This resulted in an aging of the paper itself; it took on the appearance of an old-master drawing. The superimposed material, ink in this case, became amalgamated with the original material, the paper, to form a different substance."[1]

Melvin P. Lader notes that in this drawing, "Gorky manipulated ink's expressive nature by employing techniques quite similar to those described by Schwabacher. He gently rubbed the washes of ink and gouache, possibly with a damp cloth to better work the ink into the paper, and to emphasize the warmth of the paper. Even the pen strokes that outline and model the forms are subordinated to the overall effect of the soft washes. The atmosphere of the drawing is soft, nocturnal and full of mystery, as the forms appear as shadowy presences within the modulated darkness."

The image looms larger and more immediate on this sheet, given its increased scale in relation to the paper, across which it extends from end to end.

1. Whitney 1951, p. 19; repeated in Schwabacher 1957, p. 52. Schwabacher included these statements in her general discussion of Gorky's drawings of the early 1930s. She was taking art lessons with Gorky by 1934, and presumably watched him draw using this method, or at least had long discussions with him on technique.

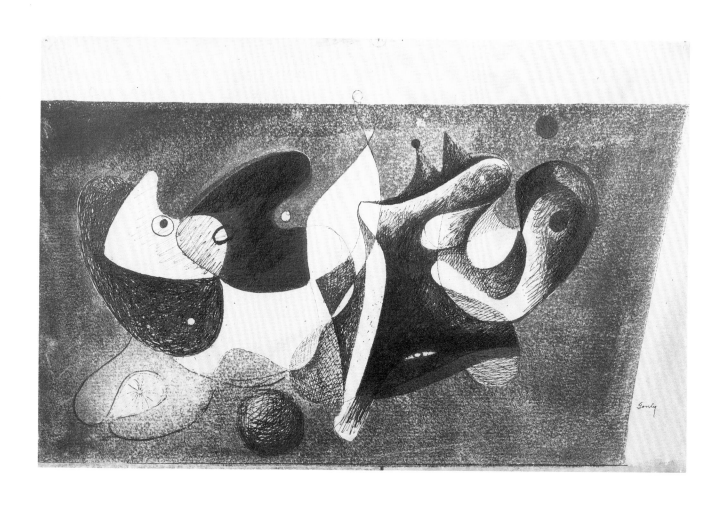

28. Nighttime, Enigma and Nostalgia c. 1931–33

Pen, brush and ink, and graphite on blue chain-laid paper

20 x 25³/8" (50 x 64.5 cm)

Not signed, recto

Signed lower left, verso: *Arshile Gorky by AGP*

Watermark, upper left, illegible

Gorky labored over many variations of this subject, evidently consumed by the expressive possibilities of drawing, especially ink, which he manipulated with a rich array of techniques and instruments. This variant is noteworthy for its dots and connecting lines in the center of the image, which could have their source in a sheet of Picasso sketches used to illustrate Balzac's *Le Chef-d'oeuvre inconnu*.[1] The scheme of the composition is revealed with ease and simplicity in a line drawing in the collection of the Museum of Modern Art (Fig. 18).

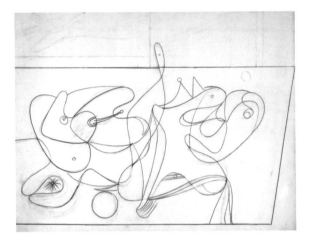

FIG. 18 ARSHILE GORKY
Study for *Nighttime, Enigma and Nostalgia*, c. 1931–32. Pencil on paper. 22¹/4 x 28³/4" (56.5 x 73 cm). The Museum of Modern Art, New York, Gift of Richard S. Zeisler

1. Reproduced in *Cahiers d'Art*, 3–5 (1932), p. 196. These drawings were taken from a book of sketches Picasso drew in Juan-les-Pins in 1924 (Zervos V, 277–327).

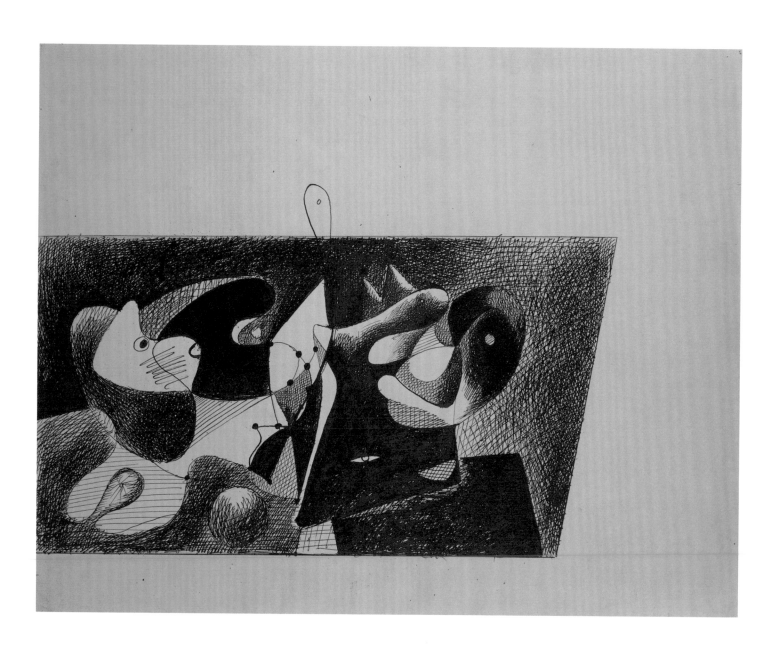

29. *Nighttime, Enigma and Nostalgia* c. 1931–33

Pen, brush and ink, and graphite on off-white chain-laid paper

18¾ x 24¾" (47.6 x 62.9 cm)

Signed lower right, in graphite: *Gorky*

Watermark, lower left: Ingres; lower right: L'ECOLIER / C & F

This pen-and-ink drawing is rather typical of the more meticulously completed versions of the *Nighttime, Enigma and Nostalgia* theme. At the left side of the drawing, a sphere, pincerlike forms, kidney shapes, abstracted heads, palettes or livers and hearts, and eyes set against a horizontally divided part-grid, part-dark field balance the two intertwined motifs at the right against another brushed ink ground. It was just such imagery and technique that perplexed the critics when works such as this were shown at the Guild Art Gallery in 1935–36. John Lane, writing for *Parnassus*, said of these drawings:

> Only four of them boast titles, one of which, Nighttime, Nostalgia, is actually quite understandable from the composition—cronies in Morris chairs blowing smoke-rings. I daresay Mr. Gorky wouldn't care if it weren't, and we are not supposed to care. Mr. Gorky's forms are still those of rememberable reality—jawbones of an ass or great rounded piano-type surfaces, "Schnozzle" Durante's, the carcass of a man with a horse's head, and what have you. A hole in one of the chairs or piano-tops seems to be a passage leading inward and covered at the end with chicken-wire, of which, in the form of cross-hatchings, Mr. Gorky employs much.[1]

The tonal values vary only slightly in cats. 29–30. Alterations occur in location on the sheet and in drawn textures. In this example, atmospheric space is abandoned and the recurring combination of diaper and opaque ground promotes a bold contrast of sinuous figure to linear ground. The scale of the trapezoid surrounded by a large void is similar in scale to cat. 28.

MELVIN P. LADER

1. John Lane, *Parnassus* (March 1936).

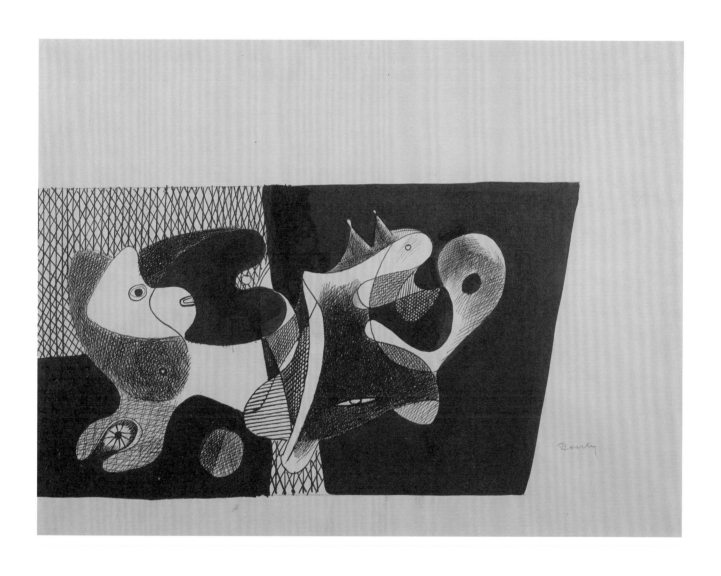

30. *Nighttime, Enigma and Nostalgia* c. 1931–33

Pen, brush and ink, and graphite on drawing board

22³/₄ x 28⁵/₈" (57.8 x 72.7 cm)

Signed lower right: *A Gorky*

Embossed lower left: STRATHMORE / USE EITHER SIDE

Once again Gorky uses the device of framing the image with a drawn line within the sheet. The *Nighttime, Enigma and Nostalgia* shape is no longer an independent form as in the previous three drawings, but defined in relationship to the graphic rectangle.

"At some point," notes Melvin P. Lader, "Gorky decided that the abstract panel incorporated in the larger thematic composition containing the head and fish images was in itself suitable for further creative exploration. In 1932 he had drawn in pen and ink one such image, now in the Museum of Modern Art (*Objects*), which is nearly identical to the undated one exhibited here (Fig. 19).[1] Much more than a date, however, can be learned from the MoMA piece. When it was acquired in 1941, the museum asked Gorky to complete a questionnaire on the work, and what he wrote can be applied to the series generally. In response to the questions, 'Was a specific model or scene used? Has the subject any special personal, topical or symbolic significance?,' the artist poetically answered, 'Wounded birds, poverty and one whole week of rain.'[2] Thus, while confirming his economic condition in the early Depression years, he also described the weather conditions that gave him time to create this exacting piece and, just as important, an implied depressed state of mind. The artist's reference to wounded birds enhances the somber mood, particularly since birds traditionally have been associated with the spirit and the soul."

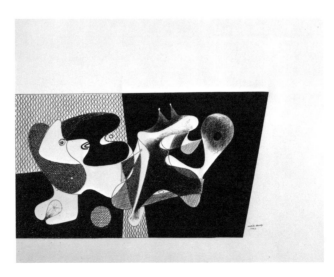

FIG. 19 ARSHILE GORKY
Objects, 1932. Pen and brush and ink on paper. 22¹/₄ x 30" (56.5 x 76.2 cm). The Museum of Modern Art, New York, Vincent van Gogh Purchase Fund

1. The Museum of Modern Art drawing on the theme is the only known dated version.

2. Museum of Modern Art questionnaire, curatorial files.

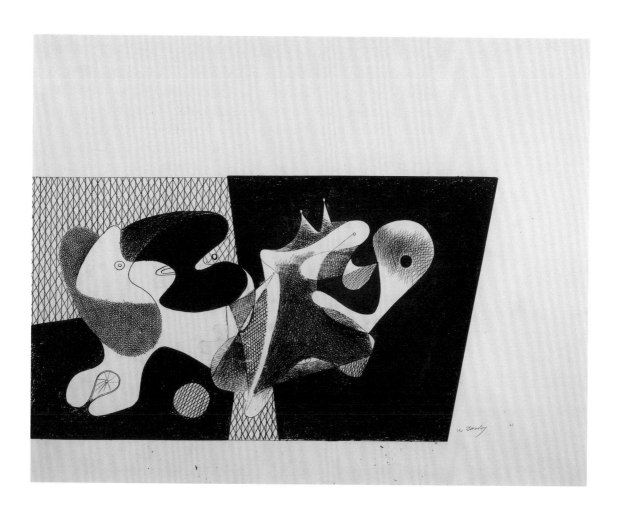

31. *Nighttime, Enigma and Nostalgia* c. 1931–33

Pen and brush and ink on heavy wove paper

22¼ x 30¼" (56.5 x 76.8 cm)

Signed and dated upper right, verso (upside down): *Arshile Gorky by AGP / 1930–32*

This drawing shares affinities with cat. 28 in its delicately illuminated space. A veil of ink wash gently envelops the abstract shapes. Lader notes, "Not as finished as most drawings on the theme, this piece reflects the range of effects Gorky was able to achieve in the medium by diluting the ink, washing, scraping, and occasionally rubbing the surface to produce a velvety nuanced appearance."

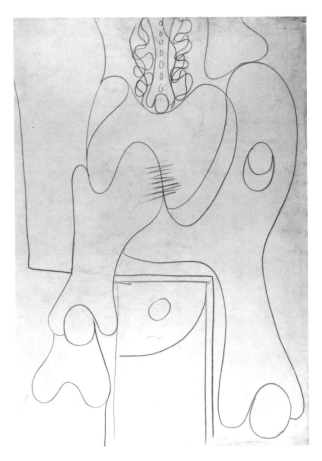

FIG. 20 Verso: graphite line drawing

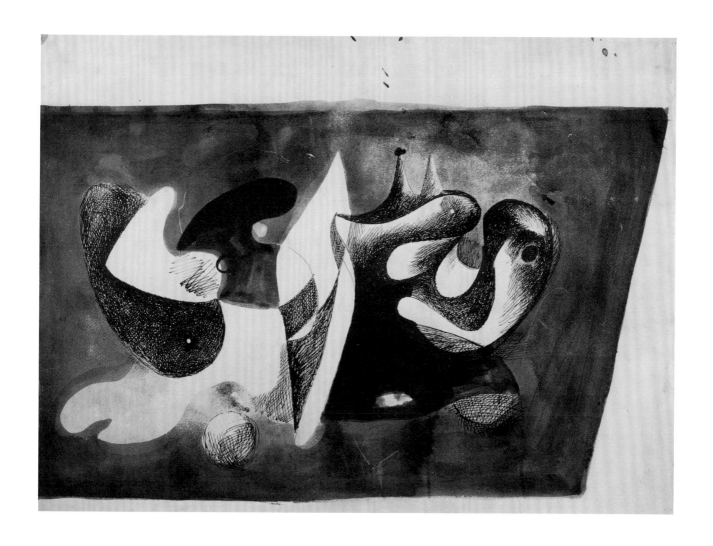

32. *Nighttime, Enigma and Nostalgia* c. 1933–36

Brush, pen and ink, and wash on heavy
wove paper

22⅝ x 30¾" (57.5 x 78.1 cm)

Not signed

Melvin P. Lader remarks, "While relating to the *Nighttime, Enigma and Nostalgia* series, this picture shows how the composition and motifs were evolving toward Gorky's mid-1930s *Image in Khorkom* theme. Among those shapes and motifs he carried over from *Nighttime, Enigma and Nostalgia* is the now easily recognizable image of a bird with spread wings at the right.

Occasionally, Gorky added brown or other colored inks to his normal black-and-white drawings, as here, and experimented with techniques and effects by using washes, or by literally washing a picture under water before further working it. The motifs in this drawing are not as structured as previously, having been freed from the continuous compositional line that governed their placement in the *Nighttime* series. Also different is the widespread use of complex hatching that unifies the pictorial field, though there is much variation in the density and placement of the hatchmarks."

The composition of many *Nighttime, Enigma and Nostalgia* drawings incorporates an abstraction within a trapezoid. This variation, however, fills the entire sheet, as in Fig. 21.

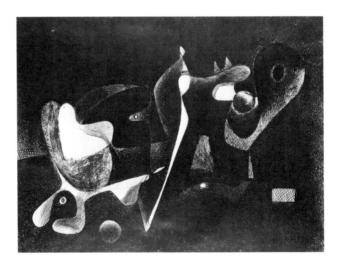

FIG. 21 ARSHILE GORKY
Nighttime, Enigma and Nostalgia, c. 1931–32. Pen and ink on paper.
20⅞ x 28¼" (53 x 71.8 cm). Yale University Art Gallery, New Haven,
Gift of Collection Société Anonyme

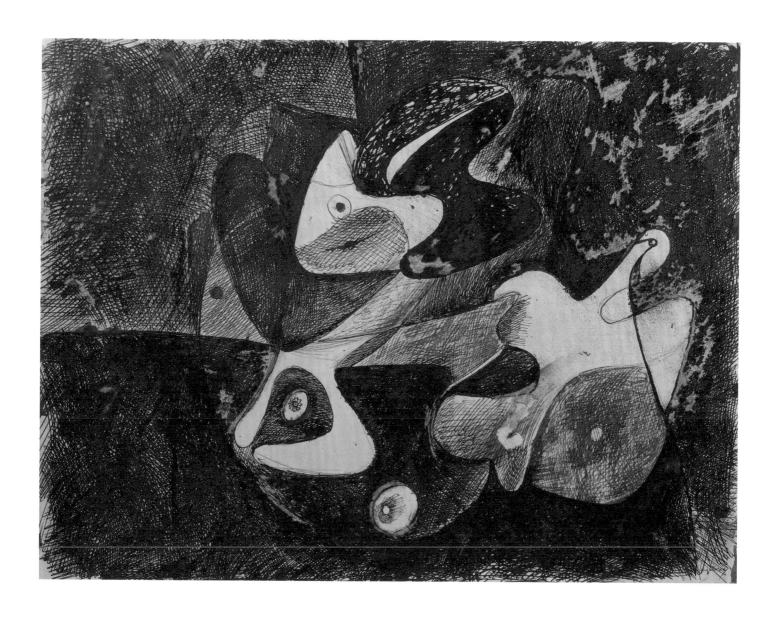

33. *Khorkom* c. 1932–34

Graphite on paper

17 x 22" (43.2 x 55.9 cm)

Signed lower right, in graphite: *Gorky*

Signed verso, upper right, upside down:
Arshile Gorky by AGP

This drawing represents a compositional and iconographic link between the *Nighttime, Enigma and Nostalgia* series and the *Khorkom* series, containing as it does elements from both. The right side of this drawing contains elements related to the former series, such as the flat interlocking biomorphic forms (here overlaid with, instead of being backed by, a hatched grid), the birdlike forms in the center, and the circle at the bottom. On the left side are elements found in the *Khorkom* drawings, most notably the roundly modeled inverted V-form and the positioning of the palette shape at the top.

MELVIN P. LADER

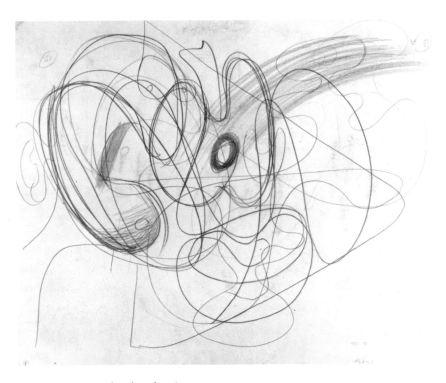

FIG. 22 Verso: graphite line drawing

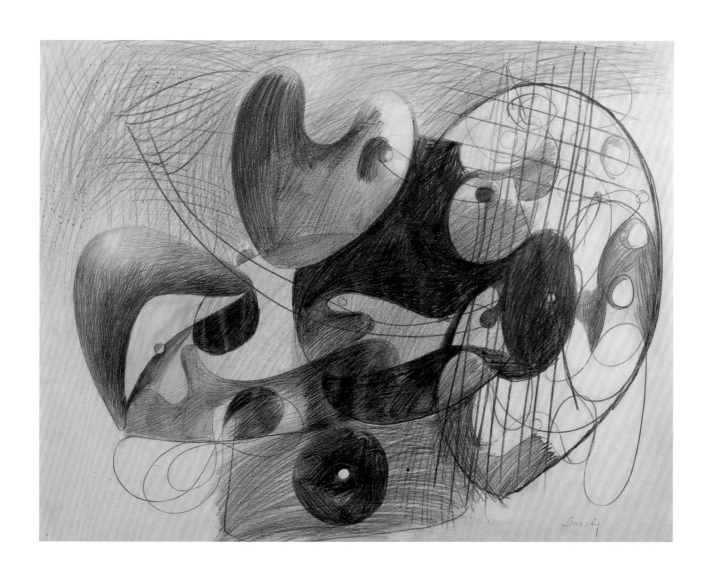

34. *Khorkom* c. 1933–36

Graphite on paper (perforated edge at top)

18¼ x 24⅞" (46.4 x 63.2 cm)

Not signed, recto

Signed lower right, verso: *Arshile Gorky by AGP*

The essential formal vocabulary of *Image in Khorkom* is easy to identify in its gradual modifications from picture to picture. Some motifs are familiar from other works. Others are unique to the *Khorkom* theme. Perhaps because of the enigmatic character of his imagery, Gorky felt compelled to discuss the context of these works. In a letter dated July 3, 1937, he described the series as follows:

> Khorkom's garden images reflected the absence of absolute boundaries in nature and the symmetry of the passage of moving matter from one state into another. The absolute and the relative were interconnected with life's paste and readily observable.[1]

In other letters Gorky refers more concretely to vivid sensory recollections of his childhood home, which he translated into pictorial terms in these compositions through abstraction rather than illustration.

1. Quoted in Karen Mooradian, "The Philosophy of Arshile Gorky," *Armenian Digest*, 2 (September–October 1971), pp. 59–60.

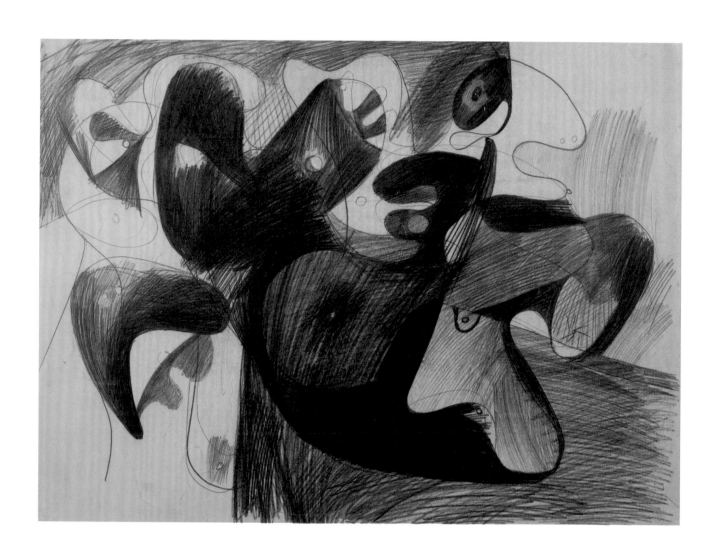

35. *Khorkom* c. 1933–36

Graphite on chain-laid paper

19 x 25" (48.3 x 63.5 cm)

Not signed

Watermark, lower center (in reverse): MBM (FRANCE) Ingres d'Arches

EXHIBITIONS: MoMA-IC 1963–68, no. 11 (*Study for "Image at Xhorkom,"* c. 1932–36)

Rotterdam 1965 no. 39 (*Study for "Image at Xhorkom"*)

College Park 1969, no. 8, fig. 20 (*Study for "Image in Xhorkom,"* c. 1932–36)

Knoedler 1969, no. 32 (*Study for Xhorkom,* 1932–36)

Lausanne 1990, no. 8 (*Study for "Image in Xhorkom,"* c. 1932–36)

In this *Khorkom*, the basic outline is possibly traced from the previous composition; however the graphic treatment is dramatically altered. Certain portions are shaded as flat planes, others are modeled to suggest their three-dimensionality, and some areas are striped or cross-hatched, always respecting the boundaries of the design. The overall effect is highly decorative and gives greater autonomy to the individual motifs in the composition.

Lader notes that, "The *Khorkom* series is the first Gorky would create based on memories of his boyhood Armenia. By no means as extensive a series as the *Nighttime* theme, *Image in Khorkom* consists of two paintings known by that title and at least eight very finished drawings."

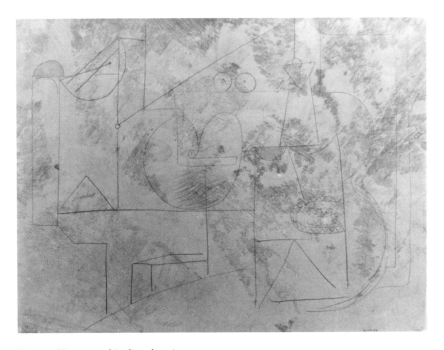

FIG. 23 Verso: graphite line drawing

70

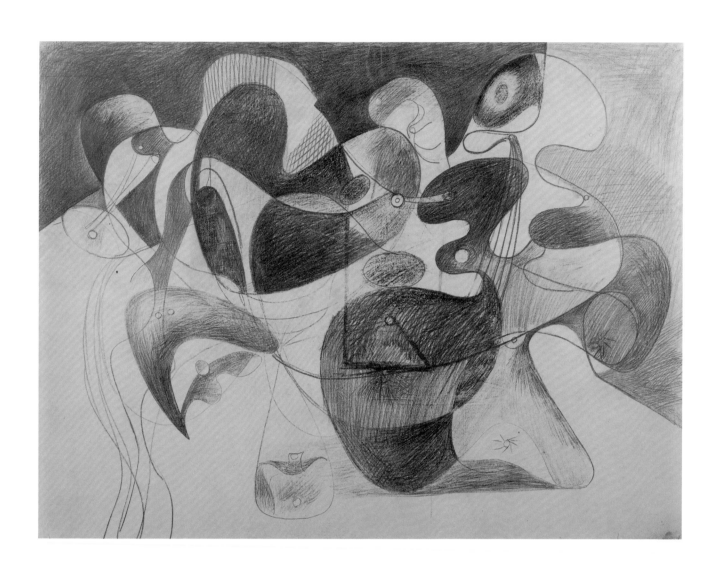

36. *Khorkom* c. 1933–36

Graphite, with some stumping, on chain-laid paper

19 1/8 x 24 7/8" (48.6 x 63.2 cm)

Signed lower right, in graphite: *Gorky*

Watermark, bottom edge: MICHALLET / FRANCE

EXHIBITIONS: Whitney 1951, no. 66, pp. 17, 19 (*Drawing*, c. 1932)

Janis 1959, no. 1 (*Xhorkom*, c. 1936)

MoMA 1962, no. 30, p. 24 (*Study for "Xhorkom,"* n.d.)

Knoedler 1969, no. 31 (*Study for Xhorkom*, c. 1932)

Guggenheim 1981, no. 52 (*Study for "Image at Xhorkom,"* mid-1930s)

Venice 1992, no. 4 (*Study for "Image at Xhorkom,"* c. 1932)

REFERENCES: Loftus 1952, pl. XI

Schwabacher 1957, pp. 49, 55, fig. 14

Levy 1966, pl. 68

Rand 1981, p. 78, fig. 5–5

The delineation of the composition once again is closely patterned on an earlier work, perhaps cat. 34, whose tracings are still visible where the outline has not been enhanced. The connective tissue is given greater substance by loose cross-hatching, producing greater cohesion among the forms. Some erasing creates a softly textured intermediary tone in the gradations from light to dark.

In 1951, Ethel Schwabacher, discussed the present pencil drawing:

About 1936 he embarked on a new phase [in his painting] in which the geometric forms of the preceding years were transformed into freer organic forms, strongly rhythmical, and in which there was a growing element of fantasy and symbolism. Among the most powerful of these works were his four versions of the *Khorkom* theme. The essential idea of this series had been developed in a drawing of about 1932.[1]

1. Whitney 1951, p. 19.

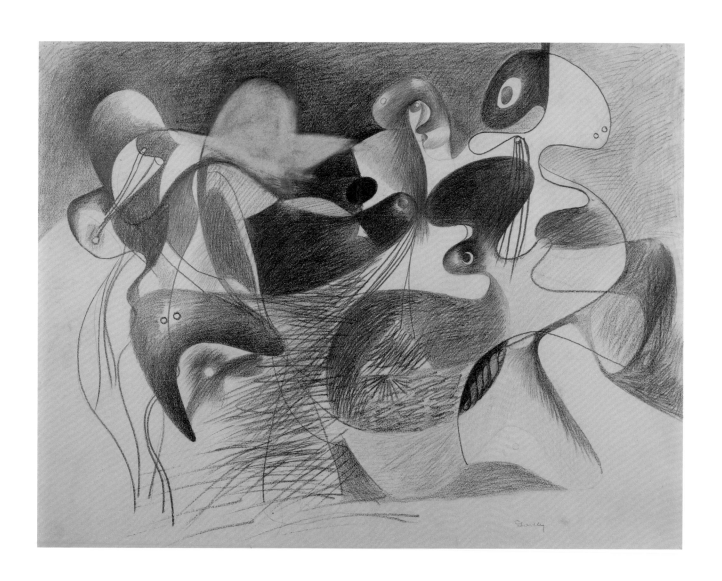

37. *Khorkom* c. 1933–36

Brush, pen and ink, and graphite on paper (with some erasing)

22³/₄ x 28⁷/₈" (57.8 x 73.3 cm)

Signed lower left, in black ink: *Gorky*

Embossed lower left: STRATHMORE / TRADE MARK / DRAWING BOARD

Gorky appears to have traced the "template" (cat. 34) onto a larger sheet of paper, and then contained the composition by a rectangular frame, a procedure he used in other themes in this exhibition. The most significant modification is the treatment of the ground, which is divided into a densely hatched section, a carefully diapered section, and a large white area. This decorative compartmentalization of the ground recalls the composite character of *Nighttime, Enigma and Nostalgia*, especially cats. 25, 26, and 29. The distinctive shape of the white surface and the addition of a cast shadow at the lower right suggest that the central form is a solid object resting on a tabletop.

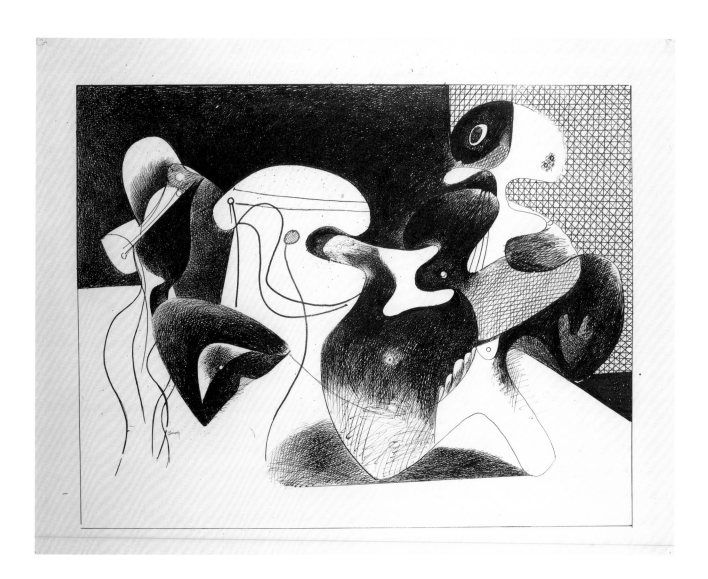

38. *Khorkom* c. 1933–36

Brush, pen and ink, and wash on heavy
wove paper

22⅝ x 30¾" (57.5 x 78.1 cm)

Not signed

Virtually all indication of three-dimensional space has been eliminated in this
richly textured drawing. Diverse pen-and-ink application, with some areas
rubbed or blotted to soften the line, other areas splattered with a mist of ink,
create an atmospheric surround. Some hatched areas have been covered with
an opaque black wash, adding a subtle dimension of black-on-black. White
areas seem almost heightened in contrast to these deep black shapes. This
elegant and tactile work most effectively conveys Gorky's acute sensitivity to
compositional and textural balance.

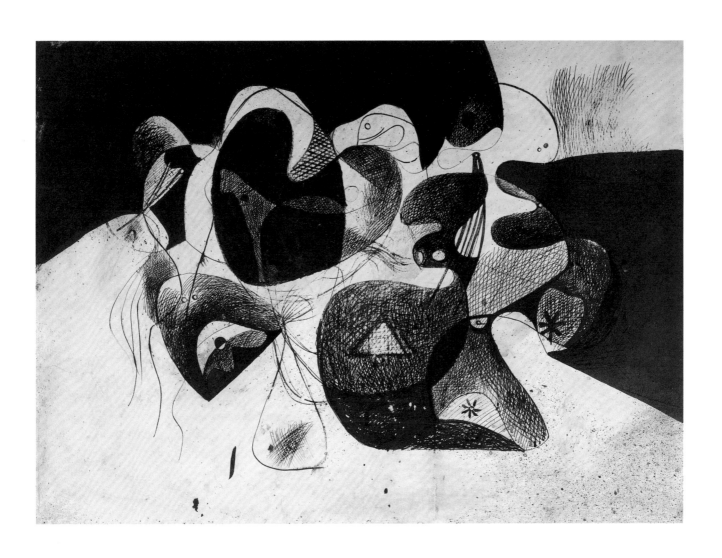

39. *Study for Mural* c. 1933–34

Pen and brush and ink on paper (with some scratching and erasing)

9³/₄ x 29" (24.8 x 73.7 cm)

Not signed

EXHIBITIONS: MoMA-IC 1963–68, no. 8 (*Study for a Mural,* 1929–32)

Rotterdam 1965, no. 22 (*Study for a Mural,* 1929–32)

Knoedler 1969, no. 20 (*Study for a Mural,* 1929–32)

Newark 1978, no. 8 (*Mural Study [Nighttime, Enigma and Nostalgia],* 1929–32)

Guggenheim 1981, no. 50 (*Untitled [Study for a Mural],* c. 1931–32)

Lausanne 1990, no. 15, p. 25 (*Untitled, Study for the Mural Painting "1934,"* c. 1934)

Venice 1992, no. 8 (*Study for the Mural "1934,"* c. 1934)

According to Melvin P. Lader, "Francis V. O'Connor first outlined the specifics of the history of the mural project for which this drawing is a design, and Gorky's involvement in late 1933 and 1934 with the Public Works of Arts Project (PWAP), the first of several art projects sponsored by the United States Government under the broad umbrella of the New Deal."[1] (For Gorky's own description of his design, see p. xii above.) According to Lader, "On January 17, 1934, Gorky reported his progress to the PWAP, noting that the title of the mural was '*1934*' and that it was suitable for placement in 'Port Authority—News Building/Building for Engineering Purposes/technical universities.'[2] He again reported progress in March 1934, but was dropped from the Project on April 29, 1934, with no official reason given.

One of the requirements of the PWAP was that each artist submit a 30 x 123-inch pen-and-ink project design, which Gorky indicated that he had started by January 17, 1934, and would finish by February 15.[3] Gorky apparently finished the design early, for on February 13, 1934, Goodrich wrote to Gorky, 'We have received your work, and would like you to go ahead with a section of it in color.' He further suggested that Gorky focus on the right side of the design in his color study and limit its largest dimension to 40 inches.[4] On March 7, 1934, Gorky indicated that he was 'carefully, working constantly' on the color sketch,[5] but its whereabouts today are unknown. The large, 30 x 123-inch ink sketch also has been lost. However, three small carefully worked out pen-and-ink sketches, including cat. 39, Figs. 24 and 25, tell us how Gorky intended the large mural to look. The composition is fairly consistent from drawing to drawing, with only subtle differences in size, details, shading and modeling."

The mural is conceived as a triptych, composed of three of the six themes examined in earlier entries. The left portion corresponds to the *Objects with Écorché* theme (cat. 22) specifically, though the *écorché*'s head has become distinctly birdlike. The central portion arises from the *Column with Objects* theme, primarily relating to cat. 8. Its classical fluted column, however, has given way to the baluster from Uccello's *Profanation of the Host* (Fig. 26). The right portion recalls *Nighttime, Enigma and Nostalgia* (cat. 26) in particular, with minor modifications, among them the foreground decoration. Never determined, however, is whether Gorky planned beforehand to merge these themes into a single mural or if the idea of their fusion arose only after each of the themes had been developed.

Uccello's predella panel, a continuous narrative that reads from left to right, provided Gorky with a model for the lateral integration of these separate, yet related compositions. The checkered patterning at the left and right lower margins of the mural design clearly derives from Uccello's checkered tile floors. Considering the two works in juxtaposition, other formal quotations suggest themselves: the E floating in a white mandorla in the upper portion of the left section corresponds to the family crest mounted over the mantle in

Uccello's first episode, and the angled panel framing the *écorché* echoes the several retreating walls spread through Uccello's panel. Uccello's predella, a structural prototype for Gorky, lent order and cohesion to his abstract imagery. Uccello was contemplated and admired by Gorky. It is known that full-scale reproductions of his work hung in the artist's studio.[6] Gorky and his colleague John Graham praised Uccello not as a master of perspective, his usual epithet, but as a master of flat abstraction and pure painting.

1. Francis V. O'Connor, "Arshile Gorky's Newark Airport Murals: The History of Their Making," in Newark 1978, p. 22.

For a general overview of the various Federal Relief projects for artists during the 1930s, see Francis V. O'Connor's studies: "New Deal Murals in New York," *Artforum,* 7 (November 1968); *Federal Support for the Visual Arts* (Greenwich: New York Graphic Society, 1969); *The New Deal Art Projects: An Anthology of Memoirs* (Washington, D.C., Smithsonian Institution Press, 1972); *Art for the Millions: Essays from the 1930's by Artists and Administrators of the Works Progress Administration Federal Art Project* (Greenwich: New York Graphic Society, 1973).

2. O'Connor, "New Deal Murals in New York." This progress report is on deposit at the Archives of American Art, roll DC 113, frames 287–289.

3. Ibid.

4. Lloyd Goodrich to Arshile Gorky, February 13, 1934, PWAP records, Archives of American Art.

5. As recorded in Newark 1978, p. 22. No reference is given for the whereabouts of this report of March 7, 1934.

6. Schwabacher 1957, p. 48.

FIG. 24 ARSHILE GORKY
Untitled (Study for a mural incorporating the imagery of *Nighttime, Enigma and Nostalgia*), 1931–32. Pen and black ink over graphite on wove paper. 18⁷/₈ x 25" (47.9 x 63.5 cm). The Detroit Institute of Arts, Founders Society Purchase with funds from Mr. and Mrs. Richard A. Manoogian and K.T. Keller Fund

FIG. 25 ARSHILE GORKY
Untitled (Study for a mural), c. 1931–32. Pen and ink on paper. 7¹/₄ x 26" (18.4 x 66 cm). Allan Stone Gallery, New York

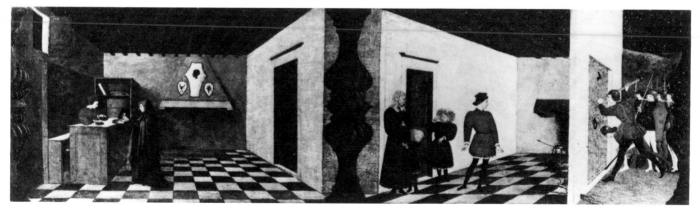

FIG. 26 PAOLO UCCELLO
Profanation of the Host (detail), c. 1467–68. Tempera on panel. 17 x 138¹/₂" (43.2 x 351.8 cm). Urbino, Galleria Nazionale delle Marche

Bibliographical Abbreviations

ASHTON 1970
Dore Ashton, "New York Commentary," *Studio International*, 179 (February 1970).

ASHTON 1992
Dore Ashton, *The New York School: A Cultural Reckoning* (Berkeley and Los Angeles: University of California Press, 1992). Reprint of *The Life and Times of the New York School: American Painting in the Twentieth Century* (New York: The Viking Press, 1973).

COLLEGE PARK 1969
College Park, J. Millard Tawes Fine Art Center, University of Maryland Art Department and Art Gallery, *The Drawings of Arshile Gorky*, exhibition catalogue by Brooks Joyner, March 20–April 27, 1969.

FINKELSTEIN 1969
Louis Finkelstein, "Becoming Is Meaning," *Art News*, 68 (December 1969), pp. 44–47.

GUGGENHEIM 1981
New York, Solomon R. Guggenheim Museum, *Arshile Gorky: A Retrospective*, exhibition catalogue by Diane Waldman, April 24–July 26, 1981; traveled.

GUILD ART GALLERY 1935–36
New York, Guild Art Gallery, *Abstract Drawings by Arshile Gorky*, exhibition brochure, December 16, 1935–January 5, 1936.

JANIS 1959
New York, Sidney Janis Gallery, *Late Drawings by Gorky*, exhibition brochure, September 28–October 24, 1959.

JORDAN 1982
Jim M. Jordan and Robert Goldwater, *The Paintings of Arshile Gorky: A Critical Catalogue* (New York and London: New York University Press, 1982).

KARP 1976
Diane Karp, "Arshile Gorky's Iconography," *Arts Magazine*, 50 (March 1976).

KNOEDLER 1969
New York, M. Knoedler & Co., *Gorky: Drawings*, exhibition catalogue by Jim M. Jordan, November 25–December 27, 1969.

LADER 1985
Melvin P. Lader, *Arshile Gorky* (New York: Abbeville Press, 1985).

LAUSANNE 1990
Lausanne, Musée Cantonal des Beaux-Arts, *Arshile Gorky: Oeuvres sur papier 1929–1947/Arbeiten auf Papier 1929–1947*, exhibition catalogue ed. by Erika Billeter, September 21–November 11, 1990; traveled.

LEVY 1966
Julien Levy, *Arshile Gorky* (New York: Harry N. Abrams, 1966).

LOFTUS 1952
John Loftus, "Arshile Gorky: A Monograph," M. A. thesis (New York: Columbia University, 1952).

MADRID AND LONDON 1990
Madrid, Fundacion Caja de Pensiones, and London, The Whitechapel Art Gallery, *Arshile Gorky*, exhibition catalogue, October 17–December 23, 1989 (Madrid); January 19–March 25, 1990 (London).

MoMA 1962
New York, The Museum of Modern Art, *Arshile Gorky: Paintings, Drawings, Studies*, exhibition catalogue by William C. Seitz, December 19, 1962–February 12, 1963; traveled.

MoMA-IC 1963–68

Arshile Gorky: Drawings, exhibition catalogue by Frank O'Hara. An exhibition selected by Frank O'Hara and circulated in the United States under the auspices of the Circulating Exhibitions Program of the Museum of Modern Art, and overseas by the International Council of the Museum. Foreign showings were accompanied by a catalogue in the native language of each nation.

Newark 1978

Newark, The Newark Museum, *Murals Without Walls: Arshile Gorky's Aviation Murals Rediscovered*, exhibition catalogue by Ruth Bowman, November 15, 1978–March 15, 1979; traveled.

Rand 1981

Harry Rand, *Arshile Gorky: The Implications of Symbols* (Montclair, New Jersey: Allanheld & Schram; London: Prior, 1981).

Rotterdam 1965

Rotterdam, Museum Boymans-van Beuningen, MoMA-IC 1963–68 exhibition, July 24–September 5, 1965.

Schwabacher 1957

Ethel Schwabacher, *Arshile Gorky* (New York: Whitney Museum of American Art, 1957).

Société Anonyme 1984

Robert L. Herbert, Eleanor S. Apter, and Elise K. Kenney, eds., *Société Anonyme and the Dreier Bequest at Yale University: A Catalogue Raisonné* (New Haven and London: Yale University Press, 1984).

Venice 1992

Venice, Peggy Guggenheim Collection, *Arshile Gorky: Works on Paper/ Opere su carta*, exhibition catalogue by Matthew Spender and Philip Rylands, April–June 1992; traveled.

Whitney 1951

New York, Whitney Museum of American Art, *Arshile Gorky Memorial Exhibition*, exhibition catalogue by Ethel Schwabacher, January 5–February 18, 1951; traveled.

Chronology

c. 1904	Born Vosdanik Adoian, Van Province, Armenia
1908	Father, Sedrak Adoian, leaves Armenia for America to avoid being conscripted into the Turkish military.
c. 1908–20	Members of the Adoian family remaining in Armenia suffer many hardships at the hands of the Turks.
1916	Gorky's two older sisters join their father in America.
1918	Mother becomes ill and dies of starvation.
1920	Gorky and his younger sister, Vartoosh, arrive in America, where he lives with his older sisters and his father in Massachusetts and Rhode Island.
1922–24	Studies at Boston's New School of Design. Late in 1924, goes to live and study art in New York City. Adopts the pseudonym Arshile Gorky.
1925	Studies briefly at the National Academy of Design under Charles Hawthorne. Enrolls at the recently founded Grand Central School of Art, where he is soon named an instructor.
c. 1927–30	Maintains a studio at 47A Washington Square South at the corner of Sullivan Street.
c. 1930	Moves to studio at 36 Union Square. Resigns position at Grand Central School of Art to devote more time to his own work.
1933	Submits proposal for a mural project to the federally sponsored Public Works of Art Project (PWAP)
1934	First solo exhibition at the Mellon Galleries in Philadelphia.
1935	Assigned to the mural division of the Works Progress Administration/Fine Arts Projects (WPA/FAP). Begins work on the aviation murals, which were ultimately installed in Newark Airport, New Jersey. Exhibits drawings at the Guild Art Gallery, New York. Marries Marney George, whom he divorces the following year.
1939	Creates mural for the Aviation Building at the New York World's Fair.

1941	First major retrospective of his works held at the San Francisco Museum of Art. Marries Agnes Magruder.
1942	Gorky and Agnes spend three weeks in the countryside at New Milford, Connecticut, where he works directly from nature.
1943	First daughter, Maro, is born. Visits and works in Hamilton, Virginia, on rural estate owned by Agnes' parents. Continues to create abstractions inspired by the natural landscape.
1944	Spends nine additional months working in the countryside at Hamilton.
1945	Resides and works first in Roxbury, Connecticut, and then in Sherman. Second daughter, Natasha, is born. Begins association with Julien Levy Gallery, where he exhibits almost annually until his death.
1946	A fire in Gorky's Connecticut studio destroys many of his paintings and art books. In New York, undergoes colostomy operation for cancer. Returns to Virginia for the summer and in a period of tremendous creativity produces 292 drawings.
1948	Gorky's neck is broken and his arm paralyzed in an automobile accident. Signs of a deteriorating marriage are evident. Commits suicide by hanging (July 2).

This catalogue was produced by Stephen Mazoh & Co., Inc.

Martin Kline, project director.

Sheila Schwartz, editor.

Printed, typeset and bound by The Stinehour Press.

Donald Crane, production supervisor.

Jerry Kelly, book design.